SHORT CUTS

INTRODUCTIONS TO FILM STUDIES

OTHER TITLES IN THE SHORT CUTS SERIES

THE HORROR GENRE: FROM BEELZEBUB TO BLAIR WITCH
Paul Wells

THE STAR SYSTEM: HOLLYWOOD'S PRODUCTION OF POPULAR IDENTITIES
Paul McDonald

SCIENCE FICTION CINEMA: FROM OUTERSPACE TO CYBERSPACE
Geoff King and Tanya Krzywinska

EARLY SOVIET CINEMA: INNOVATION, IDEOLOGY AND PROPAGANDA
David Gillespie

READING HOLLYWOOD: SPACES AND MEANINGS IN AMERICAN FILM
Deborah Thomas

DISASTER MOVIES: THE CINEMA OF CATASTROPHE
Stephen Keane

THE WESTERN GENRE: FROM LORDSBURG TO BIG WHISKEY
John Saunders

PSYCHOANALYSIS AND CINEMA: THE PLAY OF SHADOWS
Vicky Lebeau

COSTUME AND CINEMA: DRESS CODES IN POPULAR FILM
Sarah Street

MISE-EN-SCÈNE: FILM STYLE AND INTERPRETATION
John Gibbs

NEW CHINESE CINEMA: CHALLENGING REPRESENTATIONS
Sheila Cornelius with Ian Haydn Smith

SCENARIO: THE CRAFT OF SCREENWRITING
Tudor Gates

ANIMATION: GENRE AND AUTHORSHIP
Paul Wells

WOMEN'S CINEMA: THE CONTESTED SCREEN
Alison Butler

BRITISH SOCIAL REALISM

FROM DOCUMENTARY TO BRIT-GRIT

A Wallflower Paperback

First published in Great Britain in 2002 by Wallflower Press
5 Pond Street, Hampstead, London NW3 2PN
www.wallflowerpress.co.uk

A catalogue record for this book is available from the British Library

ISBN 1 903364 41 8

Book Design by Rob Bowden Design

Printed in Great Britain by Antony Rowe Ltd, Chippenham, Wiltshire

CONTENTS

list of illustrations

acknowledgements

introduction 1

1 social realism in the british context 5

2 critics, audiences, quality 25

3 the documentary movement and social realism 39

4 1950s and 1960s: social problems and kitchen sinks 55

5 1970s and 1980s: towards a social art cinema 77

6 1990s and beyond: contemporary social realism 99

conclusion 117

notes

filmography

bibliography

LIST OF ILLUSTRATIONS

1 *A Taste of Honey* 17

2 *Listen to Britain* 52

3 *Cathy Come Home* 70

4 *Saturday Night and Sunday Morning* 74

5 *My Beautiful Laundrette* 80

6 *Letter to Brezhnev* 93

7 *Nil By Mouth* 113

ACKNOWLEDGEMENTS

I would like to thank my colleagues and students at West Herts College and at Goldsmiths College for their support throughout the writing of this book. In particular I would like to thank Pauline Reay for her comments on the drafts and her constant encouragement (and sense of humour), and Ron Southwell and Ian Bell for their comments on the drafts in spite of their considerable workloads. I would also like to thank Christine Geraghty for her advice and Ivor Gaber and Keith Negus for their continued and greatly appreciated support.

Thanks also to Carol Moonlight who sourced the majority of the illustrations. Appreciation is also due to the information centre staff at Goldsmiths, West Herts College, the BFI and the British Newspaper Library at Colindale.

I would like to thank Yoram Allon at Wallflower Press for his patience and support throughout the writing of the book, and Steve Chibnall for his constructive comments on the draft.

Finally, thanks to Mo, Sacha, Pip, Richard, 'the two Julians', Bec, Joan, Lara and 'Flakey' for keeping my spirits up during these hectic last months. And love and thanks to Phil for all his patience and support.

INTRODUCTION

> As a young film-maker, I once asked Tony Garnett how Loach did this ... or that ... or the other. Garnett answered, "Alan, you're too interested in the 'how'. You have to be more interested in the 'why'".
> (Parker 1997)

This book offers an investigation of the rich tradition of social realist film-making in Britain from the documentary movement in the 1930s to the contemporary scene, or what Thorpe (1999) has termed 'Brit-Grit'. It is observed here that the various moments, movements and cycles in British social realism are tethered to their socio-historical contexts. As such, the term Brit-Grit is best understood in the context of the entire New Labour project to re-package Britain under the Cool Britannia label after the May 1997 General Election.

In her article, Valerie Thorpe argues that films like *Nil By Mouth* (1997) and *TwentyFourSeven* (1997) are evidence of a renewed interest in social realist film-making. Furthermore, she traces their lineage back to the British New Wave's kitchen sink cycle of films of the late 1950s and early 1960s (1999: 2). Alternatively, John Hill interrogates her claims and argues that Thorpe is 'too eager to identify this as a relatively unbroken tradition and to run together differing forms of film-making practice' (2000a: 249). This book takes the middle ground between these two views by asserting that whilst it may not be an 'unbroken tradition', British cinema has indeed had

an enduring relationship with social realism. In response to Hill's concerns regarding the different forms of film practice, this study goes to great pains to separate out forms and practices whilst demonstrating various continuities. The contention here is that social realism has been a major mode of expression in British screen culture that continues to this day.

Chapter 1 places the term within the historical development of realism and the cinema, before investigating it within the British framework. In so doing, it examines the term through a consideration of practice, politics, form, style and content.

In Chapter 2, it is acknowledged that social realism as a concept cannot be understood in the British context without an understanding of the terms in which social realist texts have been discussed and how such texts are perceived by audiences, critics and film theorists.

Chapter 3 concentrates on the documentary movement of the 1930s. It is widely acknowledged that the work of the documentary movement provided many of the conventions and practices used by film-makers from the British New Wave to contemporary 'Brit-Grit' films. Perhaps more fundamentally though, it is the documentary movement that visualised a different role for films in society. The conviction that films should have a social purpose, and a moral force, rather than being merely entertaining or diverting, is shared to varying degrees by all the film-makers discussed.

Chapter 4 concentrates on two strands of social realist film-making in Britain in the 1950s and 1960s: the social problem films and the work of the Free Cinema group and some of their film-makers' subsequent fictional features, often termed the British New Wave films. This chapter also considers the migration of social realism to television. It is important to note that whilst this book largely focuses on social realist film-making, it is impossible to speak of social realist film-making in Britain without acknowledging the influence and importance of television. Therefore, this book discusses social realism and television at points where to not do so would seriously impair understanding of the development of the form.

Chapter 5 considers social realism in the 1980s when, it has been noted, a resurgence of interest in social realism took place as a response to the harsh economic and social realities of life under the Thatcher administrations.

Chapter 6 picks up the story from the end of the 1980s, with the changes wrought by the Broadcasting Act 1990, and goes on to examine the contemporary scene.

The concluding chapter aims to draw together some of the main continuities and discontinuities explored throughout. It then focuses on problems, questions and issues in contemporary British social realism and invites the reader to interrogate the term 'British social realism' – how meaningful is it, not just in the global marketplace of the twenty-first century, but also closer to home?

1 SOCIAL REALISM IN THE BRITISH CONTEXT

The term 'social realism' is one which is often used uncritically and indiscriminately in popular film criticism. It is something of a catch-all term which conveys an idea of a text's content, its concerns, and its visual style. Social realist texts are described as 'gritty' and 'raw', offering a 'slice of life' or a view of 'life as it *really* is'. What makes the term particularly confusing is that it is often used interchangeably with other terms, like 'kitchen sink' realism, or 'working class' realism. This chapter seeks to unpack the term 'social realism', before moving on to explore social realism in the context of British cinema.

Realism or 'realisms'?

> In its broadest sense realism is an attitude of mind, a desire to adhere strictly to the truth, a recognition that man is a social animal and a conviction that he is inseparable from his position in society.
> (Armes 1971: 17)

There is critical consensus that realism is the dominant representational form in the Western world. Emerging from the late eighteenth century, the concept gathered force in the nineteenth century, and was a burning topic of debate amongst philosophers and artists alike. There are a number of factors that facilitated debate and motivated the desire to tell of life 'as it is really lived'. The impulse towards realism occurred during a prolonged period of social and structural change: the move from the country to the

city by thousands of workers to feed the growing industrial infrastructure (particularly in Britain); the new political ideas of communism and socialism attempting to provide a sweeping answer for the new working classes created by the industrial revolution; the secularisation of society; the 'new god' of science and its categorisations and reductive methodologies. All of these factors helped to create the context out of which the realist impulse developed.

It is largely in the nineteenth century that realism emerged as a mode of oppositional or reform-seeking expression and representation. The debates centred around literature (although painting had its own realist moment, largely centred on French painters from the mid- to late nineteenth century), and from these discussions what is termed 'critical realism' developed. There is no universal, all-encompassing definition of realism, nor is there agreement amongst academics and film-makers as to its purpose and use. But what we can say is that there are many 'realisms' and these realisms all share an interest in presenting some aspect of life as it is lived. Carroll (1996) suggests that the term should only be used with a prefix attached. This is because another important feature of all realisms is how they are produced at specific historical points. The addition of a prefix, such as social-, neo-, documentary-, specifies the 'what' and, crucially, 'when' of that movement or moment. What is regarded as 'real', by whom, and how it is represented is unstable, dynamic, and ever-changing, precisely because realism is irrevocably tied to the specifics of time and place, or 'moment'.

Realism and the cinema

By the end of the nineteenth century, literature, theatre and the fine arts were already espousing realist aesthetics, through a variety of formal and stylistic approaches and devices. The development and growth of photography brought new possibilities for capturing or invoking a sense of 'life as it is lived'. The development of film soonafter added further dimensions to the realist project, with the introduction of moving pictures and later, with the coming of sound to film. Regardless of the media used in the pursuit of the 'real', the quest was the same: to present reality, or the Truth. But Truth has as many faces as there are eyes that see it, and the search for truth through cinema was no less intensely contested than in prose, theatre or photography. Film theorist Siegfried Kracauer

([1960] 1999) believed that film was uniquely capable of representing the real and should do so with as little artifice as possible. Kracauer's conception is akin to the 'extreme form of realism' promoted by Emile Zola, that of 'naturalism'. Naturalism is an aesthetic approach first adopted in literature by Zola in such texts as *Le Ventre de Paris* (1873), *La Terre* (1887) and *Germinal* (1885). Zola contended that fictional representations of human life should aim to study, observe, and record people and their interactions in a similar manner to the way naturalists catalogued and studied the animal kingdom. For Zola this meant constructing exhaustively detailed descriptions of the worlds characters inhabited. Furthermore, this exhaustive treatment should, he argued, be extended to character formulation, development and situations. For Gerhardie the goal of naturalism is 'to resurrect the complete illusion of real life using the things characteristic of real life' (Gerhardie in Hallam & Marshment 2000: 5).

Theorist André Bazin (1967; 1971) argued that realism should provide room enough for audiences to find their own realities within realist film texts, and argued that techniques such as depth of shot and long takes would allow for this space to negotiate the realism of the text. For Bazin, realism in art is only possible through artifice as realism is an aesthetic construct (see Williams 1982). Furthermore, Bazin contends that 'there is not one, but several realisms. Each era looks for its own, that is to say the technique and the aesthetic which can best capture it' (Bazin in Southwell 2001: 140).

All of these approaches seek to represent the truth through codes and conventions that have become associated with realism. In Western mainstream cinema it is not contentious to argue that the dominant mode of representation has been realism. But clearly, whilst most Hollywood films, for example, can be regarded as realistic in setting, characterisation, situation (they have basis/reference/currency in the 'real world' they allude to), they are not necessarily realist texts. A useful way of conceiving this difference is posited by Branston and Stafford (1996) who argue that for a film to be realist as opposed to merely 'realistic' it must exhibit one of two characteristics. First, the film-maker must have intended to capture the experience of the actual event depicted. Second, the film-maker has a specific argument or message to deliver about the social world and employs realist conventions to express this message or argument. *Jaws* (1975) is set in a realistic location – a coastal holiday

resort in the then present, with figures we can easily identify in real life: the policeman and family man, the mayor, the boffin. Indeed, it is this realistic quality that, when counter-posed against the fantastical nature of the man-eating great white shark, provides the tension in the film. And though it deals with small-town thinking, and provides a critique of the profit motive, it is still not a realist text. Furthermore, *Jaws* employs some realist camera techniques in that there are moments when the style is observational, documentary-style, for example the busy Bank Holiday beach scenes. But again, the ambitions of the film are realistic rather than realist, since it invokes the real to maximise the terror of the shark to the audience. We need, then, to distinguish between what Susan Hayward terms the 'seamless realism' which produces a 'reality effect' by not drawing attention to the facts of its own illusion, and a realist aesthetic which 'recognises from the start that realist discourses not only suppress certain truths, they also produce others' (Hayward 2001: 298–9).

Defining social realism

Social realism is difficult to define not least of all because it is both politically and historically contingent. As a consequence, since society evolves and changes so too social realism evolves and changes. The term has been conceived of in a variety of ways. It is a mode of expression which can – in the first instance – be defined by what it is not. That is to say, social realist texts differ from mainstream films in a number of ways and to varying degrees. Social realist texts tend to be independent, low-budget, directed towards either the art house circuit and/or the video and television marketplace, and they stand as texts in contrast to classical Hollywood realist texts. John Hill states:

> Realist innovations take place in a kind of dialectic with what has gone before, under-writing their own appeal to be uncovering reality by exposing the artificiality and conventionality of what has passed for reality previously. (1986: 127)

From this point of view, social realist texts also stand in contrast to previous notions of realism.

A key feature of social realist texts, particularly in the British realist tradition, is the way character and place are linked in order to explore some

aspect of contemporary life in a similar way to naturalism. Hallam and Marshment further contend that this is a defining characteristic of social realism which they define as 'a discursive term used to describe films that aim to show the effects of environmental factors on the development of character through depictions that emphasise the relationship between location and identity' (2000: 184). For others, social realist texts are texts which explore contentious issues in a society, especially at moments of crisis or conflict. Lowenstein sees social realism as being 'bound up with moments of contemporary social crisis' (2000: 221).

Raymond Williams provides a helpful set of characteristics or impulses in realist works. He argues that there are four criteria under which realist texts operate that are common to all forms of realism. First, realist texts are secular. Briefly, this means that mankind has been relieved of superstition and mysticism and so is propelled towards reason and logic. It follows therefore that realist works prefer to illustrate human truth rather than divine truths. The second of Williams' criteria is that realist texts are grounded in the contemporary scene in terms of setting, character, and social issues. A third criteria is the issue of social extension. This means that realist texts tend to extend the range of characters and topics to include marginal or previously under-represented groups and issues in society. The fourth characteristic of realist texts focuses on the intent of the artist. Whilst Williams contends that this is not always the case, most realist texts are to varying degrees influenced by the political intent of the artist. Williams' criteria are useful tools in understanding realism and the increased use of realist strategies from the nineteenth to the twentieth centuries (see Williams 1977: 61–74).

For the purposes of this book and in providing the reader with a broad application of the term 'social realism', it is possible to discern three overlapping (and by no means mutually exclusive) components or aspects: *practice and politics*, *style and form*, and *content*.

Practice and Politics

Here, 'practice' is defined as the way in which a film is produced and completed – the established methods of working. In British social realism this has generally meant independent production (though as this study demonstrates this term means different things at different times), conducted in an artisanal way, and using real locations and

non-professional or little-known actors. 'Politics' is used here to refer to the purpose and intent of the film-maker. Their politics will influence their practice in that to varying degrees they will seek to be free or distinct from the mainstream, and will look to demonstrate a commitment to specific sets of ideas about the social world. Ken Loach, for example, states that 'the way you make a film is an important way of validating the ideas in it' (Loach in Fuller 1998: 114). It is important, though, to note that some film-makers have produced social realist texts in order to break into features, establish independent production companies or to join the ranks of the mainstream, thus exhibiting a range of 'intents'.

Practice and politics, by way of definition, refer to aspects outside of the text which nevertheless influence the form, structure, content and style. The mainstream Hollywood film industry is not, as the term might suggest, a unified whole. It is a mature, highly organised and professional group of industries, all in the business of selling products for mass consumption and entertainment. By contrast, film-makers whose *intent* is to show life 'as it really is' are as much reacting to the way the world is 'constructed' by the majority of mainstream films and the practices informing that construction (studio and star systems, for example) as they are commenting on aspects of contemporary social life. Furthermore, social realist texts often comment on, correct, or break away from previous conventions and practices regarded as 'realist'.

In terms of politics and practice in film-making, the different movements, moments and cycles in British social realism have been informed by a reforming or sometimes revolutionary political spirit (see Hallam & Marshment 2000). From the documentary movement, through free cinema, to the mid-1990s, British social realist texts have been propelled to varying degrees by a mission, ideal or goal. Within the text this can, in Andrew Higson's view, manifest itself as a kind of 'moral realism' (1996).

It is difficult to separate practice from politics since in many of the moments, movements and cycles, they informed each other. It is also important to recognise that a film-maker's politics influence their preferred mode of cinematic expression, which in turn limits or shapes the practice and production of texts and their place in the market. The preferred documentary form of John Grierson's film units and their conception of social purpose meant they stood outside of the mainstream film industry in Britain, but Grierson's mission to educate and inform audiences through documentary allowed him to acquire

an uncomfortable patronage from government. The lack of funds and resources encouraged the collaborative unit style of production associated with the documentary movement in Britain in the 1930s and 1940s. Their commitment to documentary 'truth', a sociological rather than an aesthetic commitment, is reflected in their practice, from the use of non-actors and 'ordinary people' to location shooting.

The British 'New Wave' film-makers' practice was also informed and shaped by their politics, which in turn placed them – initially at least – outside of the mainstream film industry in Britain. Stephen Lacey connects their practice with their political and critical stance and quotes Lindsay Anderson to demonstrate:

> The rejection of the studio system was tied closely to a rejection of a particular view of the world, which both the theatre and the cinema attacked as being 'snobbish, anti-intelligent, emotionally inhibited, wilfully blind to the conditions and problems of the present, dedicated to an out-of-date, exhausted national ideal'.
> (1995: 166)

Prior to their success with the kitchen sink cycle of films, Tony Richardson, Karel Reisz and Lindsay Anderson, along with Lorenza Mazzetti, formed the Free Cinema group, which produced creative and visually exciting short films and documentaries. The term 'Free Cinema' alluded to the principles of the film-makers, to make independent films, free from profit considerations, free from studio tampering, and with the freedom to choose their own subject matter. The Free Cinema group were influenced by Grierson collaborator Humphrey Jennings, and the work of the Italian neo-realists and the French New Wave. The Free Cinema banner was a device used to help the aspiring director attain a foothold in the film industry and it succeeded. Directors Reisz, Anderson and Richardson went on to form the hub of what is contentiously termed the 'British New Wave'. These film-makers were interested in extending the range of cinematic representation to include the working class beyond London to the industrial towns and cities of the north of England. They used unknown regional stage actors such as Tom Courteney, Albert Finney, Rachel Roberts and James Bolam, in ensemble casts. By situating their regionally authentic casts in regionally authentic locations, the British New Wave directors made new claims to realism, and made explicit through social realist fictions what was only

implicit in documentary realist texts – that character and place were interconnected, and that environmental factors where largely deterministic of a characters' fates and fortunes.

The British New Wave did not so much work outside the mainstream British film industry than *alongside* it. With playwright John Osborne and producer Harry Saltzman, the director Tony Richardson set up Woodfall Films, an independent production company, to produce their own features.

From the 1960s to the 1990s the work of Ken Loach has been shaped and informed by practice and politics. Loach's practice also eschews the use of stars, and employs location shooting in naturalistic settings, and his reasons for doing so are attached to his political beliefs and his intent as a film-maker. Loach is a committed socialist who uses documentary realist strategies to explore the inequalities and conflicts in societies. His work is particularly interesting in that it has been censored because of his political views and the subjects he chooses to explore through his features and documentaries. Loach was one of the few film-makers to make vociferous attacks against the Thatcher government in the 1980s and as a consequence the majority of his documentaries of the time were never screened (see Leigh 2002).

One important element of early social realist film practice that has changed is the collaborative, unit-style approach to film-making. The Griersonian documentary units were both collaborative and collective to the point where authorship was all but impossible to pin to one person. Indeed some films are attributed to two or more directors. Film-makers working under the banner of Free Cinema had a collective statement of principles whilst the directors of the British New Wave shared specific concerns, beliefs and practices. In the contemporary scene the movement has been towards promoting films as the unique product of one artistic imagination, via the director as author (or in the case of television dramas, the screenwriter). This theme is explored in Chapters 5 and 6 and in the Conclusion.

For the purposes of this book, the term 'content' is made up of two conjoined and constituent aspects: first, the issues and themes that social realist texts seek to explore, and second, the types of representations generally constructed. Considering content issues helps to tie films and texts to their specific moments of production and consumption and provides points of contrast between different moments, movements and cycles.

Issues and themes

Whilst by no means the exclusive preserve of social realist texts, themes and issues are important constituents. Content in terms of themes and issues is usually allied to a film-maker's intent. In British social realism this intent is often reformist, educative or socially purposive in some way, and the choice of issues and the prevalence of certain themes is bound up with a mission or a message. An understanding and appreciation of the way certain themes and issues come to the fore at different moments can reveal a great deal about social and cultural attitudes of the period studied. Furthermore, comparisons and contrasts of the treatment of specific themes and issues over different periods can prove fruitful when seeking to answer questions about why certain themes might have been central in, say, the 1950s social realist texts, but pushed to the background in later films. Because social realist texts make a claim to provide a 'slice of life' as it was or is, understanding them in their socio-historical contexts is of key importance. It is also important to remember that all texts constructed in a realist mode are always, nevertheless, constructs. Therefore, through an analysis of themes and issues, we can also determine what reality is being constructed and from which specific point of view.

At this point it is useful to distinguish between issues and themes. Issues relate to the different social problems portrayed in these films, which were topical around the time of a given film's production and which provided some cause for national, social concern. Because of the 'now-ness' (or 'then-ness' in the case of films other than the current social realist texts), because texts are fixed in and by their contemporaneous elements (as are readers of texts), issues tend to be subject to change and flux, a rise and fall in fashion. Promiscuity was more of a concern in the comparatively repressed 1950s than in the 1980s and 1990s, for example. The growth of counselling in Britain and the high media profile of drug and alcohol abuse and, more recently, child sexual abuse, has seen these issues become prominent in British social realist texts, from films to serious television dramas. These issues are also the staple of soap operas – from Nasty Nick Cotton's drug-peddling and Terry and Phil's alcoholism in *Eastenders* to the incest rife in the Jordache household in *Brookside*. Social issues, then, are more immediate and visible social fears and concerns, usually with a high media profile and, consequently,

a relatively short shelf-life. Issues are usually obvious and explicit: 'a gritty drama about unemployment', 'a raw tale of a family spiralling out of control through alcohol and drug addiction', and so on.

Themes, by contrast, are often not as explicit in the action but rather are implied. Themes work at a much deeper level and represent less obvious threats to social cohesion and stability. Themes are more descriptive of phenomena, whereas by contrast issues tend to work as labels. Thus, describing *Nil By Mouth* (1997) as a film about the family illness of drug and alcohol addiction tells us which issues are at the centre of the text. Describing the film in thematic terms gives us a deeper meaning of what lies behind the addiction issue – for example, the disintegration of working class family life or, in broader terms, the changing role of the working class in British social life from production to consumption. Themes, then, are broader, longer-lived sets of concerns usually implied within a given text. In British social realism, for example, some of the prevalent and recurring themes include: the demise of the traditional working class, changing gender roles, anti-consumerism, the negative effects of capitalism, and national identity.

Representation

It should be acknowledged that film is by and large a commercial medium rather than an educational tool. That said, it is important to note how social realist texts generally focus on characters one would not generally find in mainstream films. The representation of specific character types in realist texts has, as Williams observed, 'tended towards social extension. That is to say, extending the range of characters to include groups and individuals seldom represented on screens in mainstream cinema. Hallam and Marshment (2000) note how social realist texts draw in characters who inhabit the margins of society and who might appear in the backgrounds of Hollywood productions. Hill has noted that in British social realism, this social extension has largely involved the representation of the working class at moments of economic and social change (2000: 250). However, he also underlines how this is not simply a process of representing the previously under-represented. Rather, social realist texts also represent them from specific social perspectives. These perspectives in turn are products of distinct moments in time and are specific to the social realities of these times.

In British social realism, the social extension urge has moved film-makers to redress social and representational inequalities in relation to class. Thus the portrayals not only seek to show aspects of 'the working class way of life' but also construct these visions from specific political standpoints generated from certain sets of assumptions about what is realist and the issues and characters deemed to be within the remit of social realism. This means, in essence, that representations will be subject to change over time, with each successive social realist moment aiming to improve upon that which has gone before. This can be seen, for example, in the way the working class were represented in the documentaries of the Grierson led units in the 1930s compared with the documentary representations of Free Cinema, and the fictional portrayals of the British New Wave. Dodd and Dodd (1996) explore the dominant ideological representations of the working class in the documentaries of Grierson's unit of the 1930s. In Edgar Anstey and Arthur Elton's documentary short, *Housing Problems* (1936), the working class 'characters' are represented as victims of poor housing. They argue that in terms of representation, the documentaries of the 1930s also worked to fetishise the working class male body engaged in hard, 'honest' labour. Thus a counter-representation to the 'victim' portrayal emerges, that of male 'hero' (Dodd & Dodd 1996: 43). These kinds of portrayals are often regarded as patronising and certainly seem so viewing them at the beginning of the twenty-first century. But this aside, the social extension urge at that time is clearly seen and informed by a reforming spirit which was part of a socially purposive movement within an educative state. However, for Lindsay Anderson, British cinema had severely under-represented the working class and his work provides an example of the way social realist film-makers strive to improve upon previous conceptions of realism. Anderson states that 'the number of British films that have ever made a genuine try at a story in a popular milieu, with working class characters all through, can be counted on the fingers of one hand' (1957: 158–9; see Chapter 4 for an extended discussion).

The work of Anderson and his contemporaries represented a major break from what they perceived to be the stuffy and sterile documentary realism. The representations of working class people in their documentaries and characters in the feature films were more energetic and vibrant. This is in part due to the film-makers' fascination for the newly emergent youth culture, and a respect for the 'earthy' and

unpretentious traditional working class which these film-makers regarded as being under threat from the forces of consumerism and the influence of American culture. Anderson, Reisz, Richardson, Clayton and, to a lesser extent, John Schlesinger, brought the Angry Young Man from the theatre to the cinema, and with them came young working class playwrights and novelists, like Shelagh Delaney and Alan Sillitoe, and host of young regional actors.

So, whilst the work of both the documentarists of the Movement in the 1930s, and the Free Cinema and New Wave film-makers of the late 1950s exhibited a social extensionist urge in their work, they differ greatly in the portrayal of working class characters. What both share, however, is an overwhelming preoccupation with working class males. During World War Two this imbalance was momentarily addressed in story documentaries – a popular hybrid of documentary and feature film (see Higson 1995). For example, in films like *Millions Like Us* (1943) women were being directly addressed in order to encourage them to contribute to the war effort. In the New Wave films of the 1950s and 1960s women were often the target for the vitriolic attacks of their working class heroes, and often figured as either a threat to masculinity – through their obsession with marriage, motherhood and 'settling down' – or else as agents of consumption and at least partially to blame for the demise of traditional working class culture. Few social realist texts in this moment of British social realism offered the perspective of the working class woman. Yet there are exceptions – for example, Tony Richardson's *A Taste of Honey* (1961) and Ken Loach's feature debut, *Poor Cow* (1967). Certainly, it can be argued that the representation of working class women seems to have been most prominent in television. In television drama, Loach's *Up The Junction* (1965) and the influential *Cathy Come Home* (1966) caused controversy. *Coronation Street,* from 1960, also featured an ensemble cast of feisty working class female character portrayals, from Ena Sharples' terrifying old battle-axe to Elsie Tanner's brassy tart with a heart.

Comedies also emerged with strong working class female characters, most notably *The Rag Trade* (1961) where women were primarily situated as workers (and trade union members). In terms of cinematic representation, the gender gap was addressed in the 1980s by more female-centred social realist texts which reflected the growing importance of women in the workforce and in society as a whole. Good examples include *Letter to Breshnev* (1985), *Rita, Sue and Bob, Too* (1986), *Sammy and Rosie Get*

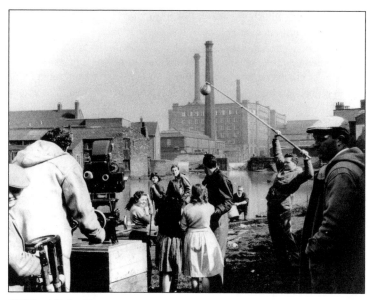

FIGURE 1 *A Taste of Honey*

Laid (1987), and the retro-social realism of *Wish You Were Here* (1989). This trend continued into the early 1990s with films like Ken Loach's *Ladybird, Ladybird* (1994), and Mike Leigh's *Secrets and Lies* (1996) and *Career Girls* (1997). In the latter part of the 1990s, however, it could be argued that the portrayal of women in social realist films in Britain has taken a retrograde step, with women being portrayed as adept consumers, unsupportive of their husbands (*Brassed Off* (1996), *The Full Monty* (1997)) or the victims of domestic violence and sexual abuse (*Stella Does Tricks* (1996), *Nil By Mouth*).

In terms of the overall representation of the working class in British social realist cinema, it has been argued that there has been a shift from representing working class characters as producers of labour to consumers of goods (see Hallam 2000). This shift from production to consumption is accompanied and facilitated by a move from depicting working class characters in communities and in the workplace, where they are more capable of collective bargaining and action, to envisioning them in the more privatised domestic and leisure-time settings.

Higson contends that a feature of British realism is bound up with changing definitions of public and private space:

> The history of the realist tradition in British cinema ... becomes the history of the changing conceptualisation of the relation between the public and the private, the political and the personal, the state and the citizen. (1995: 193)

Hill agrees and offers suggestions for this shift. For him the films of the British New Wave exhibited a shift from political to private because 'their focus on cultural aspects tended to preclude work' whilst 'their focus on the discontented male involved a down-playing of collective conditions and actions in favour of the individual and the personal' (2000b: 251). Hill sees this trend as continuing and strengthening in British social realist texts of the 1980s and 1990s and this issue is explored in Chapter 6.

It is clear, then, that in terms of representation, British social realist texts have indeed largely concerned themselves with the portrayal of the working class. It is clear, too, that British social realist films have traditionally centred on male working class characters often set in opposition to women in general. But a further distinction and observation needs to be made, that the depiction of working class characters also overwhelmingly tends to focus on white working class males. There are a few exceptions, for example *Majdhar* (1985), *My Beautiful Laundrette* (1985), the documentary *Handsworth Songs* (1986), *Bhaji on the Beach* (1993) and *Baby Mother* (1998). British social realism's sense of social extension is, in a multicultural, multi-faith Britain, as deplorable and damning an indictment as its lack of working class characters seemed to Anderson and his contemporaries in the 1950s. Furthermore, Britain has a largely invisible and shifting population of refugees, asylum seekers and illegal workers who are also rarely featured on British screens beyond news bulletins and documentaries. One film, however, does attempt to at least make a beginning – Pawel Pawlikowski's *Last Resort* (2000).

In concluding this section, it is noteworthy that the representation of working class characters in British social realist films are on the one hand being attended to within the framework of social extension, but on the other, that these texts privilege white male working class characters. In addition, in terms of issues and themes, they are in essence defined as 'prone' to the social and psychological traumas of unemployment,

violence and addiction, more in need of the awareness the spectator is implied as having (since they can see the mistakes and cycles the characters are caught in). The move from public to private, political to personal, narrows the vision to such an extent that the wider structural inequalities not just regionally or nationally, but globally, are lost from the frame. The trend towards autobiography began with directors like Bill Douglas and Terence Davies and was evident in contemporary social realist texts such as *Wish You Were Here, Stella Does Tricks, The Girl With Brains in Her Feet* (1997), *Ratcatcher* (1999) and *East is East* () can be seen as a continuation of the decline of the public to the personal. Notable, too, is that some of these texts explore the subjectivities of their central protagonists through a recreation of the past. In this respect it could be argued that such films offer a nostalgic alternative to the heritage film in British cinema. Looking back instead of looking at the contemporary settings from a highly individuated perspective can be seen as further undermining a sense of the 'public'.

Form and Style

The term 'form' is being used here to denote the shape or mode in which social realist texts exist but also to refer to the types and kinds and the 'arrangements of parts'. 'Style' refers to the aesthetic devices employed by film-makers and the artistic choices they make. These aspects of social realism refer to the specific formal and stylistic techniques employed by social realist film-makers to capture, comment on, and critique the workings of society. Form and style refer to elements within the text, though it is important to note that they may be informed by practice, politics and content.

In terms of 'form' there are four levels to be considered here. Firstly, social realism is a form of realism. We can confirm this by applying Williams' four-fold conception of the impulses of realist artists and their subsequent works. Social realism is secular in that its focuses, specifically in British cinema, are characters who are inextricably linked to place or environment. There are structural reasons for inequalities in society, which social realism posits can be seen in the effect of place on character. Social realist texts have contemporary settings, that is to say they comment or critique some aspect of life as it was when a film was produced. Social realist texts also work towards extending

the representations in art and popular culture of previously under-represented, marginalised or subordinate groups, and deal with issues and problems that mainstream cinema has shied away from or avoided.

Social realism also conforms to Williams' final criteria of realist work, in that the artist/film-maker/producer of a text often has a specific intent. In the case of social realism in British cinema, the intents of John Grierson, Lindsay Anderson, Ken Loach, and Gary Oldman are all different, but what unites their work is the presence of intent beyond the search for profit and fame.

The next conception of 'form' in terms of social realism is a consideration of the variety of artistic forms which employ social realist practices and techniques. Social realism is a mode of representation in literature, fine arts, theatre, film, radio and television. The medium has an impact on this level of 'form'.

This brings us to a further conception of social realist 'form'. For some film theorists, social realism is purely an issue of 'form' in that it is a term that enables us to distinguish between fantasy or avant garde, experimental film, animation, and so on. As this book demonstrates, there is no singular, unified social realist 'form', though the critical establishment tends to associate social realist form with television drama or gritty, low-budget feature films. In fact the range of social realist texts has varied widely in British screen culture and its impulse has informed documentary shorts of the 1930s, the popular story documentaries of the 1940s, feature films from the 1950s to the present, and in television, documentary series' soap operas, docu-soaps and so-called 'Reality TV' programmes. All of these forms exhibit to varying degrees many of the defining features of social realist texts: that there is a high degree of verisimilitude, placing an emphasis on ensemble casts in social situations which suggest a direct link between person and place. And finally, that these films, documentaries and series have something to say about 'things as they really are' in contrast to programmes and films which merely entertain.

The final conception of the term 'social realist form' relates to the last point in that the way social realist texts work is different to more mainstream products. Social realist features and dramas are structured in ways which differ from mainstream texts. First, the narrative structures of mainstream texts tend to work in a linear or cause-and-effect way, with the action motivated by a central protagonist. The texts work

towards more or less stable resolutions: the monster is killed, the criminal is caught or gets his or her comeuppance, mistaken identities are unravelled, the romantic couple are united, and so on. By contrast, the narrative structures of social realist texts tend to operate cyclically or episodically. Social realist texts resist resolutions and the future is rarely bright, though it should be said that the degree of resistance varies widely. For example, the New Wave films of the late 1950s and early 1960s tend to have a greater degree of resolution, although the futures the couples walk off into may be smog-filled. The cyclical nature of the narrative structures of later films, like *Nil By Mouth*, resist resolution. The united family at the film's conclusion demonstrates the cyclic nature of familial abuse. Although the family are seemingly happy and united at the film's end, we know that nothing has been resolved and no one will change, thus ensuring the continuation of the cycle of abuse.

At this juncture it should be noted that, whilst this book's primary focus is cinema, the links between television and film and social realism cannot be overstated. There is some contention as to whether any distinction should be drawn between the two forms. For some, like James Park (1990), British cinema has failed because its ambitions are too small, and too televisual. For John Hill (1999) any distinctions between television and film might be abandoned since all cinema has become dependent on television and video for funding and revenues.

Some film-makers see television as an important medium for social realist texts. For example, for Ken Loach part of the importance of the *Wednesday Play* season was precisely because it was on television, directly after the news. Loach states that: 'We were very anxious for our plays not to be considered dramas but as continuations of the news' (Loach in Fuller 1998: 15).

To understand social realism in Britain without a consideration of the influences and parallel developments in television at certain crucial times, is all but impossible.

Style

Initially, at least, British social realist texts were associated with exhibiting a distinct preference for content over style (this might been considered 'naturalism' to some). This led to the label 'kitchen sink', a somewhat derogatory term used to describe their perceived drab representations

of working class settings and characters. Social realist texts are often described as 'gritty', a term which can be applied to describe the surface realism of the landscapes which characters inhabit, the way these landscapes and characters are filmed and character attitudes and behaviours.[1] Social realist texts are commonly associated with an observational style of filming which tends to produce a distance between text and spectator.

British social realist texts have also exhibited a tension between a 'sociological realism' – which privileges a documenting of situations and events – and a style of social realism sometimes referred to as 'poetic realism'. The poetic realism of the British New Wave films transformed the scarred industrial landscapes of Northern England. Film critic Roger Manvell called this 'industrial romanticism' and described it in powerfully romantic terms, waxing lyrical on 'man against the black-blue sky, factories against the rolling clouds' (Manvell in Higson 1995: 192).

The poetic realism of Anderson, Richardson and Reisz was influenced by the work of Humphrey Jennings, whose own work is a good example of what Andrew Higson sees as 'an undercurrent to the educative-sociologistic tendency within the [documentary] movement which acknowledged and foregrounded the aesthetic aspects of the texts' (1995: 191). For Higson, poetic realism is where surface realism – the visual and aural signs which signify a connection to life as it is lived *within* a specific environment – and moral realism meet. Furthermore, this poetic realism works as a kind of antidote to the distance created by the cold and analytical documentary 'look', whilst its commitment to representing 'the real' helps to keep unnecessary aestheticism in check. Thus for Higson, the effect of the poetic discourse is one which 'attempts above all, to hold together the irreconcilable discourses of artistic endeavour and public service' (1995: 191). Stylistic techniques widely used to create this poetic realism include the use of sequences of establishing shots to give a sense of place, wide-angled and long shots of the urban landscape, including, most notably, a shot described as 'That Shot Of Our Town From That Hill' and explored in detail by Higson (1996: 133–4).

In contemporary British social realist film-making such a tension between sociologistic and poetic impulses is still evident within individual texts and within the tradition itself. In Britain there is a social realist tradition which embraces such diverse approaches as Ken Loach's documentary realist style, with little stylistic artifice to the hybrid styles

of contemporary texts like *Nil By Mouth* and the impressionistic work of Lynne Ramsay.

Style in British social realist texts, then, is not a simple case of presenting a 'slice of life' in any uniform way. Furthermore, social realist style has been employed across a range of genres (for instance comedy, horror and science fiction) and some techniques are now part of mainstream cinema, for example, hand-held techniques as exemplified in our *Jaws* example, above.

As the following chapters demonstrate, specific stylistic concerns are utilised at different times, in different ways by film-makers. Their use of certain styles in camera work, iconography, editing and soundtrack stand in a relationship of contrast not just between the mainstream products of the day but also to the stylistic preferences of the social realist film-makers who preceded them. Contemporary British social realist texts are increasingly identified through the stylistic approaches of single directors as authors and this issue is taken up in Chapters 5, 6 and in the Conclusion.

In the following chapter we continue our exploration of British social realism by focusing on the views of critics, academics and audiences.

2 CRITICS, AUDIENCES, QUALITY

We have seen in the previous chapter how social realism as a mode of cinematic expression is subject to intense debate. Central to this debate are the views of critics and film makers and their conceptions of the role of cinema in society and the types of film considered to be worthy of critical praise. The rich tradition of realist film-making in Britain cannot be understood without a consideration of the issue of quality. Social realist texts, from documentary to 'Brit-Grit' have, to varying degrees, been regarded as 'quality' texts because of their commitment to the portrayal of the 'British way of life'. In that sense, the pursuit of a quality cinema was the pursuit of a national cinema, distinct from its Hollywood or European counterparts. As John Ellis states in his article 'Art, Culture and Quality', this critical approach was 'established as one which placed greatest value on documentary realism, literary quality and a middle class improvement ethic' (1978: 31). Further, Justine Ashby and Andrew Higson argue that in terms of realist film-making in Britain,

> The realist tradition from the 1930s to the 1990s has always been promoted in terms of cultural value, pitting the authentic, indigenous culture of "ordinary people" against the Americanised culture of glamour, spectacle, commercialism and mere entertainment. (Ashby & Higson 2000: 9)

But as Ashby and Higson also point out, what is regarded as 'traditional' or 'indigenous', or indeed that which is regarded as being a 'quality'

product, is generated from specific ideological positions. It is necessary to be aware, then, that in speaking of a tradition of indigenous realist film-making, that it became a tradition because it was the preferred mode of expression by a relatively small elite of critics and film-makers. What is perhaps particularly notable in the establishment of this tradition is, firstly, the level of input film-makers had in the critical debates about realism, national cinema and quality, and secondly, how this socially purposive British cinema fitted in with dominant ideologies.

Critics, film-makers, quality: the 1930s and 1940s

John Grierson, Humphrey Jennings, Paul Rotha, and later Lindsay Anderson and Tony Richardson, for example, all contributed to journals and public debates in the press on the issues of realism, national cinema and quality albeit from different perspectives. Critics of the 1930s and 1940s tended to accept the documentary realist orthodoxy – that an authentic, indigenous national cinema had emerged from the documentary movement[1] (see Chapter 3 for a detailed discussion). This was made evident by the co-opting of Grierson's film unit in the war effort during World War Two, prompting producer Michael Balcon to state:

> Undoubtedly it is the influence of realism on the British film in war time which has given it its new and individual character and which has weaned it away from being an amateur and clumsy pastiche of its Hollywood counterpart. (Balcon in Higson 1995: 213)

Michael Powell echoes this sentiment, seeing the combination of the work of the documentary movement with the experiences of World War Two as the ingredients which gave British cinema its distinctive flavour:

> The influence of documentary and the experience of war ... set the English film on the path in which masterpieces are created and established precisely what was lacking in the English cinema before 1940, a traditional English style. (Powell in Higson 1995: 178)

However, this process was in evidence prior to the War. In 1932, *The Times* had already assessed the early work of the Empire Marketing Board Film Unit in terms of providing an authentic British cinema which offered

'a possibility of freeing British films from a slavish competition with American methods and of establishing for them a character of their own.' (Higson 1995: 177)

Again, *The Times* espoused a similar view in an article some six years later, entitled 'Films of Great Britain':

> Experience has shown that it is usually the short film of the documentary kind, and not the popularly conceived feature film, that presents the most authentic picture of our national life ... the modest short film, making do with things and people as they really are comes nearer to a direct statement of how we live than do the films of fiction. (Cited in Higson 1995: 186)

The critical concern over quality appeared at a time when there was much debate about the effects and influence of mass culture. Mass culture in cinema – whether the escapist fantasies of Hollywood or the more down-to-earth pleasures offered by Gracie Fields, Will Hay and George Formby films – was anathema to film-makers and critics who saw cinema as a medium for communication rather than puerile entertainment. Grierson typifies this approach here:

> I know there may be a case for filling the world's head with dreams, but one finds relief when a story of commoners stays rooted to the solid earth. We want it romanticised just the same, but we want our romance with the sweat and the smells thrown in. It's a better romance. (Grierson in Williams 1980: 112)

In terms of British criticism, this fear of the corrosive effects of mass culture influenced the debates of various left-leaning literati, including George Orwell, Leavis and J. B. Priestley. Ashby and Higson (2000) have noted how the quest for quality was often bought at the expense of deriding films popular with working class audiences. The sentiments of prominent film critic C. A. Lejeune typify this view:

> There is still unemployment, there is still shipbuilding and there is still farming. We have an industrial North that is bigger than Gracie Fields running round a Blackpool funfair. (Lejeune in Napper 2000: 115)

Richard Hoggart and the uses of literacy: the 1950s and 1960s

These views were taken on in the 1950s by critics of the New Left, most notably Richard Hoggart and Raymond Williams, both scholars from working class backgrounds, and both (but particularly Hoggart), concerned with the erosion of the traditional working class and its popular culture. Hoggart's *The Uses of Literacy* (1957) was an influential text in the 1950s and was one of the founding texts of Cultural Studies. He drew on his own experiences of growing up in the slums of Leeds to relate how affluence and mass culture had eroded traditional working class communities. For Hoggart, working class communities were traditionally bound together by material hardships from which emanated a shared culture of resistance and a palpable sense of class divisions in terms of 'us' and 'them'. Hoggart argued that communities had a strong collective tendency where importance was placed on the family and the community. Affluence and the new mass culture in all its 'shiny barbarism' was, according to Hoggart, undermining these values and destroying traditional working class cultural life. There had been concern expressed about the influence of mass culture in the 1930s by writers like J. B. Priestley and George Orwell, but it was the work of Hoggart and his contemporaries that, along with the rise of the New Left, brought these issues to prominence.

Alan Lovell notes how the concerns and representations of *The Uses of Literacy* can be seen in the documentaries of the Free Cinema movement and the films of the British New Wave. They share a 'structure of feeling which privileges and appreciates traditional working class culture whilst expressing concern about the affluent working class set to supersede it' (1996: 159). He contends that the films of the British New Wave express a specific point of view through the use of certain devices, notably landscape and townscape shots. This point of view is reminiscent of Hoggart's own position in relation to working class communities which is described as that of the grammar school boy who is looking back on his working class past with nostalgia and presenting that lost world to a non-working class audience. Thus urban landscapes are shot in such a way as to make them appear poetic or romantic.

Certain archetypes sketched by Hoggart are also evident in the films of the British New Wave. Two such figures are 'Our Mam', and 'the mester' (mother and father). In *The Uses of Literacy* Our Mam is a solid, asexual

presence contained within and defined by the domestic sphere. The 'mester' or father, by contrast, is a figure inscribed by the work he does, commanding respect from his family and community rather than love. Variations of these types can be found in the British New Wave films and later in social realist television series like *Coronation Street*.

The shift away from an interest in the working class at work to the working class at home and at play in British social realist films can also be found in Hoggart's work. But because the nature of home and leisure were changing because of affluence, increased social and geographic mobility, and mass culture, so two working classes emerged: the traditional or 'old' working class, and the affluent or 'new' working class. These classes were in turn delineated in terms of generational divides so that Our Mam and the mester come to represent a dying breed, whilst the young and affluent Angry Young Man types are seen, with some regret, as the future of the working class.

The same attention Hoggart pays to the details of working class interiors in *The Uses of Literacy* can also be found in the British New Wave films and social realist dramas of the period. Richard Dyer (1981), for example, draws parallels between Hoggart's working class communities and the community of *Coronation Street*.

Social realism: an ideological project of the 1970s

In direct opposition to the previous 'quality' debates of realism, the question of ideology is one which critics took up in the 1970s during a period of re-evaluation of the realist project in film. Whereas in previous eras critics had unquestioningly taken the view that representing the real was a worthy, responsible task for British film-makers, critics in the 1970s began to question the validity and purpose of realist film-making. This is because realism, as we have already noted, is always a social construct. Furthermore, the act of social construction, it is argued, is always tied to ideological positions. Roy Armes, for example, is critical of film-makers' inability to recognise their own ideological biases in their work, describing them as 'the university-educated bourgeois making "sympathetic" films about proletarian life but not analysing the ambiguities of their own privileged position' (1978: 264).

A series of highly influential debates in the journal *Screen* shifted the emphasis onto the possible progressive content and effect of social

realist texts. By progressive we mean content that raises questions or sparks debate about topical social issues, generally informed by a spirit of social reform.

These new critical interventions were primarily between Colin MacCabe and Colin McArthur, although other theorists (notably John Caughie) joined in from the sidelines. The debate was sparked by MacCabe's 1974 article 'Realism and the Cinema: notes on some Brechtian theses', which first sought to define the classic realist text. For MacCabe:

> A classic realist text may be defined as one in which there is a hierarchy amongst the discourses which compose the text and this hierarchy is defined in terms of an empirical notion of truth. (MacCabe in C. Williams 1980: 153)

MacCabe draws parallels between the nineteenth-century novel and film texts and argues that their hierarchies of discourse work in similar ways. Classic realist texts contain the discourses of characters emanating from their situations within the narrative. However, there is a more privileged discourse in that 'the camera shows us what happens – it tells the truth against which we can measure' the discourses of characters (MacCabe in Williams 1980: 155). This is the metalanguage of the text. MacCabe contends that because of this heirarchical ordering of discourses, classic realist texts can never be truly progressive. Classic realist texts, he argued, could not adequately explore the contradictions inherent in the real world.

Colin McArthur disagreed with MacCabe and, using a scene from Loach's *Days of Hope* (1975), argues that such texts can deal with contradictions effectively. In the scene, a mine-owner is addressing other mine-owners on the British 'way' of non-violent struggle. In the background we see soldiers drafted in to deal with the angry mine-workers practicing their bayonet techniques. For McArthur this scene demonstrates how social realist texts can deal with contradictions.

MacCabe continued the debate by responding to McArthur, in effect stating that he had proved his point about contradiction:

> While McArthur looks simply for contradiction in the text, we must look at how contradiction is produced in the audience. In the example McArthur cites, there is indeed a contradiction between

what the mine-owner says and what the picture shows. But this is exactly the classic realist form which privileges the image against the word to reveal that what the mine-owner says is false. In this manner our position of knowledge is guaranteed. (MacCabe in Caughie 2000: 107)

It is worth noting, perhaps, that around this time, a further separation or distancing seems to have been achieved between film practice and film criticism, at least in the social realist mode. The level of engagement in critical debate reached by Rotha and Grierson in the various documentary newsletter and film journals, and achieved by Anderson in the journal *Sequence*, dissipated in the 1970s. The connection between social realism in practice and in theory had been severed. This could in part be attributed to the development of Film Studies as an academic discipline, and the subsequent questioning of the realist project, which led to an interest both in terms of theory and practice, in experimental film. It should be said that these inter-related moments occurred within the context of the expansion of higher education, and a heightened intellectual interest in gender and racial politics fuelled by the prevailing counter-cultural atmosphere of the late 1960s and early 1970s. The realism debates in *Screen* in the 1970s shifted the critical ground. The idea that social realist texts could be a progressive cultural form in film and particularly in 'serious' television drama was called into question. As Caughie states: 'Being moved to tears by heart-rending content does not necessarily involve being moved on.' (2000: 109). That is to say, an emotional response to a text will not necessarily lead to increased political or social awareness nor alter ingrained attitudes and behaviours.

Revisiting, reclaiming, revising: social realism in the 1980s and beyond

The Marxist-influenced approaches of the 1970s were supplanted with a new theoretical focus – that of hegemony – in the 1980s. James Chapman (2000) identifies the moment of this approach in British film studies with the BFI Summer School in 1984, out of which the publication *National Fictions* developed. *National Fictions* aimed to address the question of how and why meanings are constructed around certain issues in specific periods in film texts, focusing attention on World War Two. It is argued that because meanings are constructed in certain ways at certain times,

they are always open to contestation and vulnerable to social change. As the *Screen* debates posited a specific relationship between films, society and audience, so the National Fictions school posited a different relation. From this perspective, culture is a site of struggle where competing ideologies constantly attempt to gain ground. Thus a re-evaluation of wartime cinema reveals more conflict between competing ideologies than consensus. In subsequent years other periods and moments, movements and cycles have been explored from this perspective to demonstrate 'that the centre of national cinema is forever shifting, forever dissolving' (Higson 1996: 8). In relation to social realism, this approach would acknowledge that there are many 'realisms' which are in a state of constant flux, since what is considered realist and realistic is always subject to contestation. John Hill's *Sex, Class and Realism* (1986), for example, argues that even the culturally conservative social problem films did not merely reflect dominant ideologies but were to varying degrees sites of struggle in terms of content and representation. In essence, this strand in British film studies is revising, revisiting and recovering cinema history.

Social realism and its audiences

The problem of what British cinema is and what it should do is a question that perplexes policy makers, critics, film financiers and film-makers. It is a question James Park describes succinctly:

> Too often producers become stuck in the middle of British film-making's essential dilemma. If they take seriously those critics who define British cinema as the antithesis of Hollywood, they're forced to reject those elements in cinema that make it possible to address audiences world-wide and secure a measure of financial success. And if they follow the argument that they should be 'projecting Britain' or 'expressing Britain' that doesn't necessarily mean they're going to appeal to youngsters in Palm Springs or Perth. (1990: 168)

As we have seen, one of the features of social realist texts is their difference from mainstream film products. This difference also indicates a specific relation that social realist texts have with their audiences. In simple terms, mainstream products are commercial enterprises generally

attracting big budgets. As a commercial enterprise a mainstream film should be looking to make a profit or at least to break even. A large budget, then, is an indication that the film is aiming to make a return on the investment, and this requires success at the box office, which in turn has an effect on the profits from video release and television rights. Success at the box office means the film is popular and, of course, audiences ultimately determine if a film is a success in real terms. Social realist texts have to compete on what many feel is an uneven playing field, in terms of the budgets available to film-makers, and the promotional and marketing capabilities of the major production companies.

The shrinking outlets for the widespread theatrical exhibition of independent social realist films is another crucial issue. It had been suggested that the advent of the multiplex would increase consumer choice; however, it has largely meant increased choice of Hollywood mainstream products. At the same time smaller chains and independent cinemas are disappearing despite a certain broadening of the film audience in the age of the multiplex, and an explosion in popular interest in film more generally. It should not, however, be assumed that all mainstream films are produced with any conception of a 'mass audience' in mind. Rather, films tend to be highly targeted towards specific demographic groups, for example *American Pie* (2000) is clearly aimed at the youth market. On the other hand, a product like *Scream* (1998) has multiple appeal rather than mass appeal: the stars beckon to the youthful audience, but the nods to the preceding teen slasher flicks of the 1980s and the irony appeal to an older, more discerning spectator. Some of the British social realist films of the 1990s and those influenced by the social realist tradition in Britain had begun to target what we might call 'the audience of multiples' with considerable success (*Nil By Mouth*, *The Full Monty*, *Bhaji on the Beach*, *Brassed Off*). However, this trend seems to have been halted, and such texts as Pawlikowski's *Last Resort*, and Lynne Ramsay's *Ratcatcher*, whilst winning prizes at film festivals around the globe, enjoyed only limited theatrical release in mainly independent cinemas before beginning their lives on the shelves in video stores.

The question is, are social realist texts less popular with audiences than mainstream products because they are not supported by the money and promotion of big production companies? Certainly publicity, usually involving stars, can and does enhance a film's ability to attract a large audience, with the constant plugging of forthcoming films on chat shows

and in magazine features. Social realist films, as we saw in Chapter 1, do not use international stars, which would undermine the film's ability to focus on the social conditions and milieu they evoke. Imagine how different Ken Loach's *My Name is Joe* (1998) would be with Tom Cruise perfecting a Scots accent and how the focus would shift away from social issues onto the angst-ridden performance of a major Hollywood star looking for an Oscar nomination. In short, having a good publicity campaign and stars is unquestioningly effective (although not always successful as *Heaven's Gate* (1980), *Ishtar* (1987), *Waterworld* (1995), and *Central Park* (2001) have shown), but not sufficient on its own. Film-makers who make social realist texts, to varying degrees eschew mainstream audiences but run the risk of being accused of 'preaching to the converted', or worse, of making films from a liberal middle class perspective for liberal thinking middle class audiences *about* (but not *for*) the working classes.

Film-makers' attitudes have shifted whilst at the same time audiences and their relationship with cinema and film culture have changed. During the 1930s and into the years of World War Two, film-makers and critics searching for an indigenous British quality cinema lamented the tastes of the masses and their apparent obsession with the glamour and escapism of Hollywood. In line with their mission to inform and educate and their obligations to do so as part of the government's information machine, the documentary movement fretted about how to appeal to wider audiences. It was not until the development of the story-documentary in wartime that that wider audience appeal was achieved in films like *The Lion Has Wings* (1939), *Target For Tonight* (1941), *Millions Like Us* (1943), and *Fires Were Started* (1943). This should, however, be taken in context. Hollywood products and British products like the Gainsborough melodramas were still extremely popular.

Despite their interest in, and respect for, working class popular culture, the film-makers of Free Cinema and the British New Wave did not want to make films with Hollywood-style mass appeal. For example, Lindsay Anderson, writing in 1948, said:

> It is today impossible to make films which will appeal to a moronic mass audience (critics should be compelled to spend their Sunday evenings sitting in front of cinema queues just looking at them), and at the same time be good. (Anderson in Murphy 1989: 232)

However, it is clear that some of the New Wave films were incredibly popular, most notably Karel Reisz's *Saturday Night and Sunday Morning* (1960). The 'kitchen sink' films were particularly popular with the young audience (16–24) which, whilst always a key group were, in the 1950s and 1960s, becoming increasingly dominant. It has been suggested that the 'X' certificates which many of these films attracted appealed to a younger audience comprised of young adults, out with friends or on dates. As Christine Geraghty observes, this began to change the social space of the cinema. In the more serious film magazines there was a distinct disapproval of this development. As Geraghty states:

> *Films and Filming* was rather gloomy about this trend and commented on the need to educate the young in film appreciation to avoid the situation in which films had to 'appeal [only] to the adolescent and emotionally immature' (2000: 7)

Cinema attendance continued to decline through the 1960s, as did social realism in cinema. The British New Wave directors took different directions – for example, Lindsay Anderson retreated into fantasy with *If* (1968), whilst Tony Richardson and John Schlesinger headed across the Atlantic as the bottom fell out of the British film industry. However, social realism was alive and well and living on the small screen in the form of gritty television soap *Coronation Street*, beginning in 1960 and still going strong into the twenty-first century. Television dramas were also becoming a staple of the social realist mode of expression. After the cosiness of *Dixon of Dock Green*, a new police drama series, *Z Cars*, was being screened on BBC television. *Z Cars* had its own gritty realist aesthetic and dealt more with the backgrounds to crimes linking criminal behaviour with social issues, place with character. Television drama seasons like *Play For Today* and *The Wednesday Play* are particularly important, not least because it is in television that one of British cinema's most consistent social realists, Ken Loach, honed his skills. Indeed, two of the landmark social realist television dramas of the 1960s were directed by Loach: *Up the Junction* and the influential *Cathy Come Home*. Not only did these social realist texts achieve large audience shares, but they also provoked public and political debate to an unprecedented scale.

From the 1960s to the present, social realist texts have been a staple of television schedules, but it is notable that a rebirth of social realist film

and television occurred in response to the harsh economic and materialist conditions of Thatcherism. Television dramas like *The Boys from the Blackstuff*, *Auf Weidersehen Pet*, and *Prospects* achieved enormous audience shares and in some cases (*The Boys From the Blackstuff* and *Auf Weidersehen Pet*), the language and mannerisms of characters entered into the lexicon of every day life (for example, Yozzer Hughes' 'Gi's a job'). The most popular sitcom of the 1980s and early 1990s, *Only Fools and Horses*, exhibited a significant social realist inheritance, from its ensemble cast to its tethering of character to their geographic and socio-economic locations. For example, the credit sequence echoes the style of British social realism by its use of a series of townscape shots including the market and the streets and estates of Peckam.

It is also significant that the 1980s saw three new 'gritty' television soaps – *Albion Market* (ITV), *Eastenders* (BBC), and *Brookside* (Channel 4). This trend was also picked up in what Christopher Williams terms a 'social art cinema' in the 1980s, although significantly, these films (*My Beautiful Laundrette*, *Letter to Breshnev*, *Sammy and Rosie Get Laid*, *Rita, Sue and Bob, Too*, *Made in Britain* (1987), for example) benefited from financial support from Channel 4. The support of Channel 4, for many, was crucial in establishing them as feature film directors (Stephen Frears is a prime example). It meant reaching a wider audience than the small independent cinemas and film festivals could manage.

During the first half of the 1980s, cinema audiences were in steep decline. There are several reasons for this including the expansion of television channels in the form of terrestrial, cable and later satellite television, the popularity of video, and more specifically, a decline in audiences in the C2DE socio-economic grades due to high unemployment and consequently lower amounts of disposable income (see Hanson 2000). Cinema audiences began to increase in the latter half of the 1980s and this trend has been largely attributed to the coming of the multiplex to Britain. But despite an increase there seems to be little room for British social realist films. Ken Loach, for example, has maintained his interest and commitment to social realism but has not made much of an impact on cinema audiences. As Geoff Brown states:

> [Loach] is a survivor, sticking to his sobering material and plain aesthetic no matter who his paymaster is. Throughout the 1990s Loach's films almost consistently won critical approval, along with

prizes at the major film festivals, yet they have made little dent at the box office. (2000: 34)

Loach has spoken out about the system of exhibition in Britain which kept his latest film, *The Navigators* (2001), from cinema screens: 'In every other European country, *The Navigators* will be screened in cinemas. Over here it will be shown first on television' (2001: 9). The idea that social realism is too televisual, too small for the big screen seems to prevail in Britain.

Mike Leigh has fared better. His most successful films to date, *Secrets and Lies*, made almost £2 million at the box office. However, these successes have to be seen in context of the financial rewards of more mainstream film products like *Bean* (1997), for example, which earned £17 million at the box office.

The lack of taste for social realist films exhibited by the cinema-going public could well relate to the expectations and experiences of the multiplex audience – or indeed any cinema audience. As Brown argues:

> The multiplex experience draws audiences that want to be taken away from their drab urban surroundings towards the Hollywood pizzazz echoed by their buildings' architecture and decor. [Loach's films] drag them back to run-down council housing, to the benefits office, or back to school for a history lesson about the Spanish Civil War or Nicaragua: places audiences do not want to go to. (2000: 34)

This chapter has explored the term 'social realism' and placed it within the British context in terms of film practice, critical debate and its importance in British film culture. The following four chapters offer a detailed consideration of some of the major movements, moments and cycles of British social realism from the 1930s to the contemporary scene.

3 THE DOCUMENTARY MOVEMENT AND SOCIAL REALISM

We begin our exploration of British social realism's different movements, moments and cycles with the documentary movement. The term social realism tends to be applied to British films beginning with the fictional feature films of the British New Wave. However, the Free Cinema group and the British New Wave directors were noticeably influenced by the work of Humphrey Jennings, a film-maker who produced all of his film work within the documentary movement. In addition, the Free Cinema and British New Wave film-makers were responding to the version of reality constructed by the documentary movement as well as to British mainstream films. Finally, as Andrew Higson (1996) notes, the British New Wave films also inherited certain conventions from the documentary movement.

Projecting the unknown England

> No one now shares Paul Rotha's judgement made in 1936 that the documentary film movement is "this country's most important contribution to cinema as a whole". (Dodd & Dodd 1996: 38)

In spite of the above statement in terms of understanding social realism in the British context, the documentary movement of the 1930s and 1940s is crucial for a number of reasons. Firstly, the documentary idea posited a different role for film in society. For the documentarists, film had a social purpose and a role to play for the betterment of society rather

than just as mere entertainment. Secondly, and allied to this point, it did so through a belief that it could benefit British society, helping to forge a sense of national identity and belonging. Thirdly, the documentary movement brought issues and representations to British screens which had not been featured before. Feature films of the period tended to portray working class caricatures rather than full-bodied characters in their own right, and as plot ancillaries rather than as the central focus. Fourthly, the documentary movement pioneered practices which would become the markers that distinguished its output from mainstream film. These practices helped to determine the practice of future film-makers working in the social realist mode. So, whilst Dodd and Dodd may well be right that no-one now sees the documentary movement's films as 'Britain's outstanding contribution to world cinema', it certainly is central to the development of social realist practice and production in the British context.

The label 'British Documentary Movement' is generally applied to a group of film-makers and the body of films and writings they crafted between the late 1920s and the mid-1940s. This movement in turn became associated with a mode of cinematic expression described as 'documentary realist'. The origins of the movement can be found in the state-sponsored sector and developed out of the state's public relations programme, first as the Empire Marketing Board Film Unit (1927–33), then later disbanding and reforming as the General Post Office Film Unit (1933–39). The GPO Film Unit was put to work in the war effort and became part of the Ministry of Information during World War Two, when, as the Crown Film Unit, it produced propaganda films. The unit also made films for companies, both private and public sector – for example, the British Gas and Coke Company, Shell Oil, and the BBC.

Making documentary films outside of the mainstream features market was never going to be profitable – although some of the wartime films were commercially successful. Grierson railed against what he perceived to be the 'Woolworth intentions' of the commercial film industry. As Leo Enticknap states, Grierson argued 'that the need for films to be financially successful was often culturally disadvantageous' (2000: 209).

From the 1930s to the late 1940s the films of the various units had specific social concerns and set about educating the public about all manner of topics. One of the most significant aspects of their output is the way that working class people were represented. Paul Rotha, for

example, argued that the work of the Empire Marketing Board Film Unit 'represented the first attempt to portray the working class in Britain as a human, vital factor in present day existence' (Rotha in Higson 1995: 197).

Things became bleak for the movement towards the end of the 1940s. By the beginning of the 1950s, the agreement to distribute the unit's work between the Cinema Exhibitors Association and (what had now become) the Central Office of Information had ended. The Crown Film Unit was terminated by the newly elected Conservative government. But the movement's influence was felt in the newly emerging television current affairs output and across the globe as its former members settled in other countries and helped to set up similar film units. The unit style of work was unique and has since been much copied. The units developed a specific practice of collaborative working, which Annette Kuhn describes: 'A model of collaborative work [was] adopted which embodied characteristically 'pre-capitalist' or early capitalist artisanal relations of production' (Kuhn 1980: 27). This artisanal approach is corroborated by one of the movement's early members, Alberto Cavalcanti: 'The working conditions were similar to medieval artisanship; the work was collective, the films of each one were discussed' (Cavalcanti in Kuhn 1980: 27).

John Grierson is often attributed as the founder of the documentary movement, and it is certainly true that Grierson's contribution, influence and energy were pivotal to the movement in its early days, and for sustaining the documentary idea in film journals and the quality press decades after its 'golden age' in the inter-war years. Grierson-trained technicians travelled to many countries and helped to establish national schools of documentary film-making. Grierson's philosophy of documentary film-making also influenced contemporary television documentary production, and whilst some later film-makers, especially those associated with the Free Cinema Movement, reacted against Grierson's patrician tendencies and elitist assumptions, they have still been influenced by it. He was the first to use the term 'documentary', in February 1926, describing Robert Flaherty's *Moana* (1925), in a film review in the *New York Sun*. He coined it from 'documentaire', a term used by the French for describing travelogues. This connects directly to a body of nineteenth-century literature termed 'The Unknown England' texts, whose middle and upper class authors wrote about the hitherto unknown areas of working class Britain. As Dodd and Dodd point out, the

documentary movement had much in common with this body of work and they compare the stated intentions of one of its authors with Grierson: George Simms writes of the need to travel 'into the dark continent that is within easy walking distance of the General post office' (Simms in Keating 1976: 107), and Grierson of his desire to 'travel dangerously into the jungles of Middlesbrough and the Clyde' (Dodd & Dodd 1996: 41).

For Grierson, documentary film was 'the creative interpretation of actuality'. His work with the units should be seen in the light of a change in social attitudes, the desire to build a sense of national identity, to educate the public.

> The basic force behind [Grierson's intentions] was social and not aesthetic. It was a desire to make a drama from the ordinary to set against the prevailing drama of the extraordinary: a desire to bring the citizen's eye in from the ends of the earth to the story, his own story, of what was happening under his nose. (Hardy 1979: 59)

Another key member of the movement, Basil Wright, echoed Grierson's original sentiments stating that: 'The primary interest of the true documentary director is sociological' (Wright in Kuhn 1980: 180).

To some extent Grierson has come to be associated with all that was passionless, soulless and stuffy about the documentary movement in the 1930s. However, we should recall Grieson's own definition of the documentary idea, that it was the *creative interpretation* of actuality rather than the unreconstructed reflection of the real world through the camera's lens. So whilst initially he chose film as the medium for his sociological explorations, his position changed over the years:

> Most people ... when they think of documentary film think of public reports and social problems and worthwhile education and all that sort of thing. For me it is something more magical. It is a visual art which can convey a sense of beauty about the ordinary world, the world on your doorstep. (Grierson in Aitken 1990: 11)

It is important to emphasise that the movement was not an homogenous and unified whole. There was a distinct tension between the sociological and the aesthetic articulated through the notion of poetics which we will explore later in the chapter.

The documentary movement, propaganda and the state

The movement has been much criticised in subsequent decades, not least for its propagandist function. The state was well aware of the power and potential of film as part of its public relations programme directed at a new mass audience. As Sir Stephen Tallents, head of the Empire Marketing Board Film Unit said in 1935: 'For the State, the function of official documentary is to win the consent of this new public for the existing order' (Tallents in Higson 1995: 196).

The state was willing to provide funds and support provided the films met their standards in terms of technique and subject. As the first director of the Ministry of Information's Films Division, Sir Joseph Ball, made clear in 1939:

> We can ... finance and help to finance some of the best British documentary film producers for the production of short documentary films approved by us ... provided such films are of first class quality. (Ball in Chapman 2000: 198)

Some film-makers in the units were particularly uncomfortable with state patronage, and Grierson himself had a characteristically contradictory view, and had various disputes with his paymasters over particular films. For example, in the early days, he was ordered by the Empire Marketing Board's Film Committee to take out the montage scenes from his own film *Drifters* (1929) before release was granted. Grierson obliged but put them back in at the last minute (see Hardy 1979).

Grierson was frequently frustrated by the bureaucratic interventions and distractions of the state machine and wrote with acidic clarity of his experiences: 'Say it in triplicate ... quote your authority. Flag me a ref. Register and Return. Put away and bring up for action in six days ... or three. Christ and I thought to make movies' (Grierson in Hardy 1979: 50).

Humphrey Jennings, another key figure in the documentary movement, registered similar concerns and frustrations with the state-sponsored system. In a letter to his wife about the release of *Listen to Britain* (1942), Jennings notes:

> The picture about music called *Listen to Britain* is now finally finished and everybody likes it very much but I don't know when

it will get on the screen – some pretty deep battles developing here between Ministry and big business: although in fact the Government have been carefully good – much too good to them. (Jennings in Jackson 1993: 56)

Harry Watt observes how insignificant he is in the Ministry scheme of things. After making the highly successful *Target For Tonight* (1943) he notes:

Strangely enough, I have never been able to find out anything about the money side of *Target*. This is, I imagine, because, while the Ministry distributed the film, the receipts went direct to the Treasury ... Incidentally, it won a wartime Oscar in America, which I never even saw. (1974: 17)

The problems of propaganda were neatly avoided by Grierson because he defined it as 'elucidation' and 'understanding'. Propaganda was civic education and promoted civic understanding and citizenship as well as helping to cement national identity particularly during the years of World War Two (see Kuhn 1980).

This sentiment might seem unconvincing today but it reflects an – albeit naïve – idea that the state had the best interest of all the peoples of Great Britain as its priority. But the documentary movement and its films were the products of particular cultural and political moments which influenced other fields, including theatre, social anthropology (perhaps most notably mass observation[1]), photography, painting and radio, and social documentation can be found across all forms (see Higson 1995). As such, the documentary movement's approach reflected the wider trend towards social democratic thinking. Whilst some in the Ministry of Information and certain members of the Conservative Party distrusted what they perceived to be the left wing sentiments of some of the units' film-makers, it has been argued that politically, the Griersonian units offered a 'third way', that of the social democratic approach to cultural practice. It is important to note, however, that there is little evidence to suggest that the majority of film-makers in the Units supported this political stance, though certainly the moral tone of the work is strongly suggestive of the influence of a reformist spirit centring on a broadly humanist, socially democratic moral philosophy.

The units' film-makers were providing a state-sponsored public service to include a far wider conception of 'the public' than had previously been achieved. Even though the films were made for government and the nationalised industries or commercial sponsors, many of the film-makers had a different view of who and what their films were for. For example, Edgar Anstey and Arthur Elton, the directors of *Housing Problems*, saw their film about the slums of the East End of London as not being theirs at all but 'the slum-dwellers' film' (Higson 1995: 197). Close analysis of *Housing Problems*, as Higson notes, presents the working class figures as essentially passive, allowed to speak on cue and contained and visualised by a 'public gaze' which has underneath it a 'fascinated gaze' (1995: 194). The film positions the spectator at a distance to the 'characters' on the screen, whilst making an implicit challenge to the spectator to be sympathetic to the plight of the people featured. This sympathy is the film's moral force, that slum dwellers are to be pitied and helped to 'catch up' with civilisation. This moral force is delivered by the film's use of voice-over, coupled with the use of montage, as well as the dramatic framing and lighting of the people we meet in their 'real' environmental contexts. At the same time the gaze which appeals to the spectator as a citizen, is fascinated by the homes and interiors of the slum dwellers and their habits and how they cope with the conditions in which they live. This fascination is somewhat akin to the interests of the Unknown England authors. At the beginning of the film a series of establishing shots takes us from high above the streets of the community to the roof-tops, then down into the narrow streets and alleyways, beckoning us in from the outside to the very heart of the working class interiors. We are on a journey not only into an 'Unknown England', but also to a misunderstood community. So whilst it is probably true that Anstey and Elton did put the working class on the screen, it was from a certain perspective: as victims who could not help themselves and who needed aid from the state and sympathy from society.

Humphrey Jennings demonstrated the moral responsibility he felt he had in filming the miners for his story documentary, *The Silent Village* (1943). A film committee comprising of local people was set up in the village to discuss any issues and met regularly to discuss shooting, the script and any problems. Jennings makes clear why this was important: 'We didn't want the film to be an inch out – to the village, to Wales, to Lidice, to the miners' (Jennings in Jackson 1993: 67). For Jennings, then,

part of documentary film's realism implied a moral responsibility for the film-makers towards those represented.

Another documentary luminary, Harry Watt, stated that all of the units' work was informed by what might be seen as a socially democratic humanism:

> We set out to dramatise reality and give a dignity in films to the everyday person and the everyday event (Watt in Higson 1995: 198).

Claims to art and poetic realism

Clearly the film-makers of the documentary movement were involved in the production of state propaganda, but propaganda was defined as education and clarification by its leading figures. Another strategy adopted to avoid the unpleasant associations with propaganda was to promote the documentary film in terms of art.

The movement's film-makers, particularly Grierson as its figurehead, felt themselves to be absolved from accusations of crude propaganda because of their films' claims to be of artistic merit. As Higson states, 'documentary might have aspired to the status of a democratic mode of communication, but it also aspired to the status of high culture, a serious, socially responsible, and artistically respectable cultural practice' (1995: 195). The films of the documentary movement aspired to become, in effect, public service art. And as Higson points out, it was the documentary movement which in Britain 'captured the interest of film as art' (1995: 187).

Part of this claim to art was underlined by the 'poetics' of the films they produced. Grierson used the term 'poetics' to describe how he wanted to express the grandeur and struggle of the life at sea for his North Sea fishing fleet in *Drifters*, allowing him to convey 'that atmosphere of higher meaning without which no drama is any drama at all' (Hardy 1979: 50–1).

Film-makers of the New Wave were influenced by the poetry of Jennings' wartime documentaries. Lindsay Anderson went as far as to claim that Jennings was 'the only real poet the British cinema has yet produced.' (Anderson in Jennings 1982: 53).

Higson believes that the tension between social purpose and poetry was a central feature of the movement's work and has called this

'poetic realism' (1995: 191). He argues that simple surface realism was inadequate and that the force of poetic realism not only tempered the stiff and clinical sociological tendencies, but also imbued the films with a moral realism, that is to say an intent or a commitment to attend to certain problems and issues from a sober and reasonable standpoint. Attendant to this was a deep sense that cinema had a duty and a responsibility beyond entertaining the masses. For Higson, poetic realism 'involves a more perfect conjunction of surface realism and moral realism, a conjunction which transcends ordinariness, which makes the ordinary strange, even beautiful – but above all, which has emotional depth and integrity' (1995: 190–1).

World War Two

The Second World War proved to be a pivotal time for the documentary movement. A hard-core of British film critics as well as leading figures in the documentary movement and in British cinema more widely were lauding documentary as 'Britain's outstanding contribution to film as a whole', and it was seen by these writers, film-makers and critics as an indigenous 'quality' cinema. As Chapman states:

> Roger Manvell, Paul Rotha and Basil Wright ... belong to the same tradition as the leading film critics of the war years (such as C. A. Lejeune, Dilys Powell and Richard Winnington) and are imbued with the same aesthetic principles that privileged realism and notions of quality. (2000: 194)

As we have seen in the previous chapter this search for a quality British cinema was a preoccupation with the aforementioned film-makers and critics. During World War Two the realist impulse came into its own and the documentary movement and its supporters were the major force behind it. As Chapman says:

> British cinema was deemed to have discovered a new aesthetic of sober, responsible realism, derived in large measure from the documentary movement. It was a time when a genuinely British national cinema was seen to have emerged, one that dealt with the current realities of British life, and particularly with the various

processes of social change brought about by the impact of war. This realistic aesthetic was articulated through the marriage of the studio feature and documentary technique and style can be evidenced in two ways: through the kinds of features being made, praised by critics and attended by audiences and through the cross-over of staff from the documentary units to studios like Ealing, and the subsequent cross-pollination of ideas from the commercial sector into war-time documentaries. (2000: 194)

The features were very popular with audiences – though it is important to note two things: first that they were not the only films popular with audiences (Gainsborough melodramas were enormously successful, for example), and second, the wartime realist-influenced features began to lose popularity in the mid-1940s, when the trade decided that the public had had enough of war-related films. Nevertheless, films which brought together documentary realism and feature film conventions were well received by critics and audiences alike and we can include a veritable canon of films of this type – *The Lion Has Wings* (1939), *In Which We Serve* (1942), *Nine Men* (1943), *Millions Like Us* (1943), *San Demetrio, London* (1943), *Target for Tonight*, and *Fires Were Started*. According to Roger Manvell, 'the war film discovered the common denominator of the British people' (Manvell in Chapman 2000: 194). Andrew Higson has argued that by aiming to produce a harmonised 'one nation, one goal' effect, such films worked to obfuscate class differences and inequalities. He states that one of the major functions of the propaganda machine during the war was the 'creation of ideological climate in which the public sphere could be represented as a sphere of national interest immediately and widely recognisable as over and above any antagonistic, sectional interests' (1995: 213).

In terms of representation these films attempted to flatten out the cultural and class differences that so preoccupied the documentary movement. Gone were the working class victims of *Housing Problems*. Working class characters were now unbound by the voice-overs of the well-meaning, middle class film-makers and the camera's gaze worked to demonstrate how in times of war the former bank manager must work alongside the street sweeper to beat the enemy and preserve and protect Britain. Part of the propaganda function of these films, therefore, was to convince audiences that everyone had something at stake be they rich or poor, middle or working class, male or female. During World War Two

British cinema did not so much 'find the common denominator' but rather construct it for propaganda purposes.

Criticisms of the documentary movement

Overemphasis on Grierson can lead to an impression of continuity, both in terms of practice, politics and style, that the work of the documentary movement did not have. Moreover, it downplays the significant contribution of others. Claire Johnston (1980) has noted that the overemphasis on the Grierson's units and its film-makers has helped to mask the film-making activities of a range of groups, such as the Trades Unions, the Labour Movement and the range of amateur film societies producing documentaries, enabled by advances in film technology.

As naïve as it might sound today, many intellectuals and artists were convinced that the state could become the site of neutral communication between the government and the governed, simply because it was for the nation's good and also free from the pressures of commercial enterprise. In subsequent decades the documentary units' have been deeply criticised for this stance. Yet to say that the documentary movement had its critics and enemies is an understatement, most of them working in hindsight and retrospect although certain members of the movement itself were privately critical of Grierson and the units' state-sponsored status. Also the trade was often hostile towards the movement largely because they resented the competition from films funded by government and the efficiency of the units, whilst others envied the wide network of non-theatrical distribution Grierson had striven to set up.

Beyond these gripes are more serious criticisms. The movement has been criticised for its complicity with the state, and for its seemingly patronising representations of the working class. It has been criticised for its propaganda function and for its political and ideological conformity. As Ian Aitken states:

> The activities of both units, since they operated as part of a government public relations programme, were ultimately delimited by the requirements of state propaganda. (1990: 30)

The generation of film-makers after the World War Two deemed the work dry and stuffy and vaguely patronising. For example, Lindsay Anderson states

that 'the Griersonian tradition ... was always more preachy and sociological than it was either political or poetic' (Anderson in Jennings 1982: 59).

Other, more recent, evaluations of British cinema have concluded that the British Documentary Movement has received too much attention, which has led to other cinemas being forgotten or lost and the task of re-discovery (of the quota quickies of the late 1920s and early 1930s, or silent films, for example) continues (see Richards 2000).

Aside from its impact on British film studies, the movement has had a tremendous influence on film culture and practice in Britain as well as influencing, indirectly, television production and content – for better or worse. In the case of the latter, Stuart Hood has argued that the documentary movement and the ideas of Grierson have been internalised by television (and film-makers), and responsible realist texts – whether they are dramas, news bulletins or documentary programmes – are transmitted by a largely neutral mass media. Hood states:

> [Grierson's] ideas have been used by contemporary television and film-making practitioners to institutionalise a doctrine of balance which has reinforced political claims for the neutrality and fairness of established society and the mass media. (Hood in Aitken 1990: 9)

In terms of influencing film-makers, despite the Free Cinema group's dislike of the Griersonian legacy, one of its key members, Humphrey Jennings, was a major influence, first on their documentary output and later their feature films.

Case study: Listen to Britain

Jennings directed and co-directed a total of only 23 films, most of which were short documentaries, all under the state-sponsored system in Grierson's film units. Doubtless he would have continued as a successful film-maker, painter and poet had his life not been cut short by an accident in Greece in 1950. Jennings was a major influence on many future film-makers, including the group of directors collectively known under the label Free Cinema (see Chapter 4). Jennings' expressive and lyrical visual style puts him at odds with the work of, say, Edgar Anstey and Arthur Elton. A feature on Free Cinema in *Sight and Sound* attempts to put Jennings in his context:

Free cinema was, of course, preceded by John Grierson's documentary movement in the 30s, but it was oddball aesthete Humphrey Jennings whom its proponents held up as an influence not the civil service functionaries behind the majority of Grierson's films. (Dixon & Dupin 2001: 29)

And yet as Jackson (1993) points out, Jennings would have been one of these functionaries himself, given that his access to money and equipment would have been restricted and that work would have to be approved by the Ministry of Information before it could be released. Jackson marvels at how such a seemingly unassuming character should come to be considered as one of the world's finest directors. After all, Jennings was 'just one among many hired hands for the Ministry of Information's wartime propaganda effort; at best one might say, a minor, poorly paid civil servant' (Jackson 1993: ix).

Jennings did not confine himself to film-making. He was on his way into an academic career prior to his work with the Units. He was also an accomplished surrealist painter and a poet. All Jennings' work aspired to create an 'imaginative truth' (Penrose in Jennings 1982: 4). His best films are considered to be his wartime works: *Words For Battle* (1941), *Listen to Britain* (1942), *Fires Were Started* (1943), and *Diary For Timothy* (1944).

Listen to Britain was made and released in 1942 as the documentary-influenced film was reaching its heights in terms of popularity with audiences and the approval of critics. It was, according to Jennings, 'a film about music' (Jennings in Jackson 1993: 56), and based on an idea he had formulated called *The Tin Hat Concerto*, a day in the life of Britain: a Britain at work and at play but also at war. In terms of form, it is a documentary short with a narrative structured around 24 hours in the life, work, and music of Britain. *Listen to Britain* maintains the musical theme of the original idea which extends the definition of music to include the music of labour, machinery, and of city and country. This music features alongside more conventional forms, from piano recitals to Flanagan and Allen's canteen concerts. In the soundtrack the two 'musics' intertwine and at times it is difficult to discern which 'music' is playing. The soundtrack thus creates a unity and a harmony between the two. Whether at work or at play music binds the nation.

The images work in a similar way, as Jennings juxtaposes scenes of rural calm shattered by the fly-past of screaming fighter planes, with images of

FIGURE 2 *Listen to Britain*

rugged coastlines and bruised but beautiful industrial townscapes. *Listen to Britain* is a visual and aural concerto: all elements work hard to contain the variety and diversity of wartime Britain whilst producing a smooth surface of a Britain united. Thus the unity in visual imagery and soundtrack reflect and reinforce the unity and harmony of Britain. For if there is one message that stands out from *Listen to Britain*, it is that in Britain diversity creates harmony. However subtle and ingenious this may be, the film clearly works effectively as propaganda. For here in Jennings' film, social, cultural and gender differences do not matter since a common identity and set of values are shared by all. *Listen to Britain* reconstructs what Britain is fighting for and how she did it, a key function of the state's propaganda machine (see Chapman 2000).

Listen to Britain shares an interest in the representation of sites of labour and men at labour with the earlier films of the movement – for examples see *Drifters*, *Industrial Britain* (1933), and *Coalface* (1935). We are taken on a whirlwind tour of steelworks, munitions factories, the armed services. It is also quite typical of Jennings' work in that, according to Lovell (1996), leisure time is ordered around work. This figuring of leisure is, according to Higson (1995), one of the unique

features of Jennings' work and one which clearly influenced the film-makers of the British New Wave. Jennings provided a 'new iconography' which they would develop in their own documentaries under the Free Cinema banner (*O! Dreamland* (1953), and *Momma Don't Allow* (1956)) (1995: 202). Jennings had already explored this 'new iconography' in *Spare Time* (1939). What is interesting is how harmony and unity continue to be fore-grounded in this new iconography. As Higson states: 'This new iconography depends upon the representation of leisure as a community activity, with an emphasis on group shots or wide shots of large masses of people rather than close-ups on individuals' (1995: 202). A good example of this can be seen in the scene in the ballroom at Blackpool, a wide shot of the dance-floor crammed with waltzing couples who variously smile at, avoid, ignore, or fail to spot the camera trained on them. Inter-cut with this scene are two soldiers at dusk on the sea-front. They remind us that Britain is at war, but that Britain can still, as a nation and en masse, enjoy its spare time.

As propaganda, *Listen to Britain* was subtle, touching and effective. In terms of film as art it breaks new ground for the wartime documentary as well as conveying a poetic vision of a country dealing with crisis. As a social realist text *Listen to Britain* – as a wartime picture – is atypical since it portrays Britain and the British as one diverse but unified nation at a time of massive social upheaval.

The emerging social realism of the 1930s was co-opted for the war effort. Issues of class and deprivation were all but forgotten and the justi-fication for this it seems was that everyone, regardless of class and social status had the same problem to resolve and the same enemy to defeat.

Jennings, then, is somewhat unique in the British documentary movement of the 1930s and 1940s. Although he shared similar interests and concerns with his contemporaries in the movement, Jennings' subtle, lyrical sense of form and style certainly qualify him to be considered a true poet of British cinema. And yet Jennings, like the documentary movement more generally, worked collaboratively. In spite of familiar Jennings motifs and imagery (corn fields, rugged coast line, starkly contrasted with urban landscapes), *Listen to Britain* is not credited to a single author as Jennings insisted on sharing the film's credits with his editor, Stewart McAllister.

Jennings' poetic legacy inspired some of the key directors of the next decade. In the following chapter we examine this legacy in the section on Free Cinema and the British New Wave.

4 1950S AND 1960S: SOCIAL PROBLEMS AND KITCHEN SINKS

Britain's continuous relationship with a realist tradition progressed in the post-war era with two distinct social realist strands: the social problem film, most associated with producers Michael Balcon and Michael Relph, and director Basil Dearden, and the poetic realism of the British New Wave directors – particularly Tony Richardson, Lindsay Anderson, and Karel Reisz. Both strands can be seen as having been directly influenced by the documentary realist project, in different ways. In this chapter we begin by looking at the social problem films of the 1950s before going on to explore the Free Cinema movement and the 'kitchen sink' cycle of films by the directors of the British New Wave.

The social problem film

From the early to mid-1950s a particular type of film emerged which was primarily concerned with the exploration of issues in contemporary society. Although fiction, these films can be seen as a continuation of the documentary movement's mission to inform and educate citizens, by exploring contemporary concerns through the medium of film. Because of their seemingly straightforward aim of tackling issues of social importance in a 'realistic' way, these films were considered to be quality British films. Once again, quality is associated with realism, which in British cinema is associated with educational, socially purposive films, rather than with vehicles designed for pure pleasure and entertainment, or 'tinsel'. Quality films made a positive contribution to the social good.

A range of issues were covered by social problem films in this period, notably youth, gender, sexuality, incest, religious fundamentalism, and racial intolerance and inequality. But, as the generic label would suggest, these issues were explored first and foremost as 'problems'. The realistic, contemporary settings, and the concern with contemporary social issues, mark these films out as social realist. However, their status as fiction films for mainstream exhibition required conventional narrative structure, which tended to mean these films first posited the 'problem', which then had to be represented and explored in the world of the film, and finally and most crucially, the 'problem' had to be resolved within that constructed world. Consequently, many of the dominant ideological beliefs and attitudes of the time thread through these texts.

Degrees of resolution vary in these texts. For example, *The Blue Lamp* (1950) uses a process of doubling to eradicate the threat of Dirk Bogarde's 'bad boy', leaving the preferred image of youth in the form of Dixon's young protégé. By way of contrast, *Sapphire* (1959) has a more uneasy sense of resolution. Certainly the murderer is apprehended and both Leroyd and Hazard have learned lessons about racial inequalities, but the film's resolution does not suggest that the problem of racial intolerance has gone away.

Social problem films are linked to the documentary project in a number of ways. Firstly, their explorations and discussions of issues of national importance and interest is reminiscent of the subjects of the various Grierson units, which also tackled social issues. Secondly, the films can be seen as having a similar function from the perspective of the film-makers. One of the most prolific producers of social problem films, Michael Relph, argued that cinema as a mass medium must exercise 'social and educative responsibilities as well as artistic ones' (1961: 24–5).

Thirdly, many of the personnel who had worked in the documentary units during the World War Two went to Ealing Studios (Alberto Cavalcanti, Harry Watt, for example), and this is where director Basil Dearden made a large number of social problem films.[1]

As with the films of the documentary movement, the films of the 1950s' social problem cycle, to a degree, reflected and reinforced dominant ideological positions. These positions tended to be manifested in two ways: by the obfuscation of class inequalities, and the repression of (usually sexual) desire (see Barr 1977). This is evident from the choice of 'problems' the films focus on, the perceived 'cause' of the problems

selected, and the solutions available to solve the selected problem. Furthermore, the national appeals contained within these films tend to stress the universality of the problems in question, which in turn excludes social explanations relating to class, gender, sexuality or racial inequalities.

This is not to say that the social problem films in question simply represented and reproduced the dominant ideological assumptions of the times. As John Hill notes, there are different degrees of ideological coherence. But clearly, there is some degree of inter-relationship between the representation of the 'real world' in these films, and the dominant ideologies of the period (1986: 122). That said, the social problem cycle of films did extend representation to include a diverse range of social groups and archetypes. Some of the films also dealt with controversial issues, sometimes going against the grain of popular opinion.

For all their high-mindedness, the social problem films of the 1950s were constrained by the conventional treatment of the very social issues they sought to explore. The conventions of mainstream narrative fiction, the realist tendency in British cinema, and the ideological climate of the time all tended to work against radical and political readings. But class, gender, race, sexuality were not fixed, closed issues as they were lived and experienced, but were, in the wider society, open to debate, and constantly contested. And yet the social problem films of the 1950s, in the final analysis, give an illusion of consensus, of a nation in agreement as to the rules and norms which govern and structure its peoples.

Free Cinema and the British New Wave

From the late 1950s to the mid-1960s, British cinema underwent a kind of renaissance. It is certainly true that something had changed in British cinema. There were new voices, new film-makers who, despite breaking with previous traditions, nevertheless continued to advance the realist project in cinema begun some thirty years earlier by Grierson and his film units. Nina Hibbin sums up the changes concisely:

When *Room at the Top* hit the screen in 1959, it signalled the beginning of one of the most exhilarating bursts of creativity in the history of British cinema. During the following five or six years new film-makers with fresh ideas brought to the screen a sense of

immediacy and social awareness that had people queuing again after nearly a decade of decline. (Hibbin in Hill 1983: 303)

As Hill contends the major breakthrough achieved by the so-called British New Wave directors can be seen in the way they actively sought to represent a group previously marginalised in British cinema: the working classes.

The Free Cinema movement took its name from a programme of film screenings at the National Film Theatre between 1956–59. The screenings were the idea of three young aspiring film directors: Tony Richardson, Karel Reisz and Lindsay Anderson, and conceived of as a way of breaking into the film industry in Britain. Between them, the directors made many of the landmark social realist films of the late 1950s and 1960s: *Look Back in Anger* (1959), *Room at the Top* (1959), *Saturday Night and Sunday Morning* (1960), *A Taste of Honey* (1961), *The Loneliness of the Long Distance Runner* (1962), *This Sporting Life* (1963). These directors, along with Jack Clayton and John Schlesinger, are often described as the British New Wave, a term which relates them to the French New Wave. The formal and stylistic characteristics of the British New Wave have also been described as heavily indebted to the French New Wave, which drew criticism from the British critical establishment.[2]

The documentary work of the movement's founders constitutes a break from the Griersonian sociological representation of social issues. However, they were influenced by the poetic style of Humphrey Jennings – Lindsay Anderson stated that Jennings was one of the few poets British cinema has produced, despite his associations with the Documentary Movement. He wrote:

It comes as something of a surprise to learn that this unique and fascinating artist was from the beginning of his career in films an inside member of Grierson's GPO Unit and made all of his best films as official, sponsored propaganda during the Second World War. (Anderson in Jennings 1982: 53)

The concerns which underpinned the work and practice of the Free Cinema movement were, according to Jim Hillier and Alan Lovell:

A sympathetic interest in communities, whether they were the traditional industrial ones ... or the new, improvised one of the jazz

club ... fascination with the newly emerging youth culture ... unease about the quality of leisure in an urban society ... and respect for the traditional working class. (1972: 172)

Free Cinema was constituted by two 'freedoms': freedom from commercial constraints and considerations, and freedom to choose the subjects that interested them as artists. Thus, the subjects for their Free Cinema shorts were youth culture (*Momma Don't Allow* (1956), Reisz and Richardson), and the decline of the traditional working class and their leisure pursuits (*O, Dreamland* (1953), Anderson). These issues would become prominent thematic concerns for Richardson, Anderson and Reisz in their transition to feature films. As we saw in chapter 1, Anderson noted that:

> The number of British films that have ever made a genuine try at a story in a popular milieu, with working class characters all through, can be counted on the fingers of one hand ... This virtual rejection of three quarters of the population of this country represents more than a ridiculous impoverishment of the cinema. It is characteristic of a flight from contemporary reality. (Anderson in Hill 1983: 127)

Anderson and his contemporaries' later work in features set out to redress this imbalance, by enriching British cinema with an enhanced and expanded version of contemporary reality. This reinforces John Hill's (1983) assertion that innovations in realist cinema tend to expose the artifice and conventionality of the 'realism' that went before. It can also challenge the claims to realism of other media. For example, in pointing out the differences between New Wave theatre and film, Stephen Lacey argues that the films of the New Wave 'opened out the action' and that the result of this is that 'far more of society in which characters move is actually shown' and this adds to the realism (1995: 169).[3]

It is easy to see the British New Wave as a continuation or re-packaging of Free Cinema. There are significant differences which should be emphasised as all too often the two bleed into each other because of the film-makers whose work unites the two. First, Free Cinema was a movement with ideals and certain interests, not least of all freedom in terms of style and content, practice and politics. The term British New Wave was a term applied by critics to the work, partly in response to realist moments in theatre and literature. These critics would in turn be

influenced in their labelling by similarities they perceived between film-makers such as Anderson, Richardson, Reisz, Clayton and Schelsinger to the French New Wave film-makers largely because of their fascination with the details and minute rituals of everyday life, the interest in ordinary people and their dialects, and their use of location shooting. However, it is perhaps Italian neo-realism which most influenced the British New Wave directors. Neo-realism is a term used to describe certain films emerging from Italy after the Liberation (between 1943–48). These films employed location shooting in their practice, focused on ordinary working people and were committed to getting close to their subjects. The neo-realist film-makers' intent was imbued with a liberal, left-wing humanism evident in their sympathetic treatment of working people and their problems within the wider context of the impact of large-scale societal events. Long takes worked to create a greater textual space for observation, and narrative structure was episodic, with loose motivations. Examples of neo-realist film-making can be found in Rossellini's *Rome, Open City* (1945), De Sica's *Shoeshine* (1946) and *Bicycle Thieves* (1948), and De Santis' *Bitter Rice* (1948) (see Hallam & Marshment 2000).

The influence of Italian neo-realism can be seen in a host of different national new waves that rippled out across Europe in the late 1950s to early 1960s. Second, the Free Cinema movement worked mainly in the documentary form whereas the films of the British New Wave were feature films. These films are variously described as working class realism, kitchen sink realism, or simply as social realist texts and, as it has been observed elsewhere in this book, the terms are often used interchangeably.

Third, and perhaps crucially, the British New Wave film-makers were not a collective, and they did not mount the kinds of NFT screenings that the Free Cinema group did. Rather, they produced films for an independent commercial production company, for widespread mainstream release.

In spite of these major – and important – differences there are still certain continuities in terms of style and political concern. As Lacey argues:

On the one hand, there is a certain continuity in visual style from documentary to feature film ... and, on the other, many of the intentions that surfaced in Free Cinema can also be traced in

the commercial films – especially the fascination with traditional working class culture and the ambition to represent what is contemporary about contemporary Britain. (1995: 167)

This concern to represent the 'now-ness' of contemporary life in Britain reinforced the claims to realism of both the Free Cinema documentaries and the feature of the British New Wave film-makers.

In terms of practice, location shooting was preferred. Richardson, particularly, disliked working in the confines of studios, choosing instead to work within the limitations each specific location imposed, even for interior scenes (see Murphy 1992). Making films within the relative security of Woodfall Films (the production company set up by Richardson, playwright John Osborne and American producer Harry Saltzman) meant that the same crew could be used over and again, which brings to mind the collaborative style of Grierson's units. However, a difference in terms of practice between the documentary units, and the British New Wave was that the latter did not have to compromise their political or artistic integrity by working for a state agency or industrial sponsor. This was as far as freedom from commercial constraints could take the British New Wave films, since Woodfall itself was a fairly conventional film production company which fitted unproblematically within the mainstream British film industry. As such, then, their films still had to be distributed by larger companies, often relying on American finance, which meant box-office receipts and favourable critical reviews were as necessary to them as they were to other companies producing films at this time.

The use of regional actors with regional accents was also a practice established by the British New Wave, and clearly links with the film-makers' political viewpoints about the under-representation of working class characters in British film at that point. However, whilst the work of the British New Wave film-makers certainly improved the chances of working class actors getting screen exposure, they were not responsible for creating this pool of fresh acting talent. Sanderson (1984) argues that the increase in working class actors by the mid-1960s can be attributed to a number of factors, including the number of local authority grants for drama students, coupled with the attendant rise in drama school graduates, as well as the opportunities created for working class actors by social realist theatre and television. As Lacey puts it: 'The result was a pool of actors who could respond to the demands of the new plays and,

in doing so, shift the parameters around what was considered "real" and "authentic"' (1995: 67). Actors such as Albert Finney, Tom Courtney, James Bolam, and Rachel Roberts, were largely unknown on the screen, having made their names in theatre. So, not only did the New Wave extend the range of cinematic subjects, it also gave regional, theatre actors the opportunities to break into the national (and international) film scene.

The British New Wave films were often attacked by the critical establishment for their apparent aping of the techniques of the French New Wave, notably, the adoption of subjective filming techniques which, for some, resulted in the 'egotisation of the world' (Hill 1986: 134). Undoubtedly, as keen aestheticists, the British New Wave were influenced by these techniques – yet their films' use of an authorial voice, and objective point of view, constrained the so-called 'excesses' of the French New Wave.

The key to understanding the visual representation of social realism in the British New Wave films of the late 1950s and early 1960s can be found closer to home, in Grierson's definition of 'documentary' as the creative interpretation of actuality. As we saw in chapter 3, Grierson's interest in film was primarily sociological rather than aesthetic. Jennings, on the other hand was interested in a poetic cinema. The British New Wave shared Jennings' view. The creative interpretation of the social world was achieved through the use of poetic realism in their work. The 'authors' use recognisable units of meaning in a way that goes beyond the surface realism of mainstream 'realistic' film and documentary realism, in order to get at 'poetic truths'. Poetic truths are human, existential truths, and run counter to social facts. The implication is that social facts are really surface facts – things that can be counted, categorised, labelled, and accounted for. Poetic truths have deeper, universal and existential concerns. Thus for the British New Wave film-makers, film should not merely reflect the surface realities of everyday life, but should penetrate that surface to reveal human truths.

A number of stylistic conventions can be determined in the social realist films of the British New Wave. As Lacey notes, these films helped to create a public language, a framework for interpretation, and they were able to do this in part by establishing various iconographic and stylistic features.

The use of 'place' as place rather than setting tends to create a curious disjunction between action, location and character. According to

Higson, narratives require space in which the action can unfold. However, because the British New Wave make claims to realism, certain shots – most notably townscape and landscape shots – must be more than just spaces for narrative action. Since they are shot in real locations they demand to be read as 'real historical places'. In effect they become 'signs of reality' and serve to authenticate the realism in the text. However, Higson (1996) contends that since these films are realist fictions there is a tension between the demands of the narrative – the need for the narrative to work in a story-telling space – and the demands of realism – the need for place to authenticate fiction as realist. Higson argues that this tension is often overcome by landscape and townscape shots being integrated back into the narrative by transforming place into a signifier of character or a metaphor for the states of minds of characters.

Such landscape and townscape shots work to create and preserve a certain distancing between the spectator and the figures on the screen. Lacey (1995) usefully points out that this distance is not a critical distance but rather an observational one. For him the observational gaze is permissible because of the underlying commitment to moral realism, that is to say its commitment to a set of values and beliefs about the social world and cinema's role within it. It could be argued though that it is this distancing aesthetic which articulates social difference. As Higson puts it, 'it is only from a class position outside the city that the city can appear beautiful' (1984: 18).

Specific shots – extended sequences of establishing shots, or the familiar image explored in Higson (1996) of 'The Shot of Our Town From That Hill', work to distance spectators and characters from the action, like poetic pauses, offering space for reflection. The choice of locations – factories, empty railway stations, seaside towns in winter, cobbles and back allies, work to create a poetic milieu, which has been referred to as the aestheticism of urban squalor.

In line with the enthusiasm of Free Cinema for experimentalism and technical and artistic innovation, the New Wave social realism was punctuated with formal features: extended montage sequences backed by and cut to either melancholic or energetic jazz scores, creative camera work that frees the camera to join the action, through the use of angled shots, and hand-held effects. A good example of the latter can be seen in Tony Richardson's *The Loneliness of the Long Distance Runner* (1962) in the sequences when Colin is enjoying the heady freedom of his early

morning cross country runs. Another example is the fairground sequence in *Saturday Night and Sunday Morning* as music, editing and camera angles combine to mirror not only the bumpy ride on the waltzer but also to imply the similarly bumpy and dangerous plight the clandestine lovers are experiencing as they are pursued.

A number of criticisms have been levelled at the work of the British New Wave and their poetic realism. First, their technical and aesthetic experimentalism was seen by some critics as at odds with a realist cinema. These critics felt that the gimmicky use of the camera and the stylistic flourishes not only detracted from the realism of the representation, but in fact made the films 'dishonest' in that they were perceived to be more concerned with the director's artistic licence than the social messages they purported to contain.

A similar criticism is levelled at the British New Wave's use of locations as place rather than setting. The aestheticism of squalor and the poetics of place can also be seen as undermining the social messages, and can be seen as romanticising the decaying infrastructure of industrial Britain.

Whilst many of the male working class heroes at the centre of the films of the British New Wave are described as 'Angry Young Men' it is also indicative of another criticism of the social realism of these directors. While Anderson, Richardson, and Reisz certainly extended the cinematic subject range in Britain to include the Northern industrial working class, the focus of these films largely centred on working class male protagonists. Conversely, the representation of women, working class or otherwise, tended to be somewhat negative by comparison. In these films, women are represented as the social agents of consumerism. They represent a threat not only to traditional working class culture, but to men in general.

It can certainly be argued that the breakthroughs in representation forged by the British New Wave and their working class realist texts are severely limited and fatally undermined by their misogyny. Lovell (1996) argues that there are clear gender divisions in the way place, space and setting are used in these texts. For example, women are associated with the domestic sphere whilst men are seen to occupy public spaces.

Hill (1983) believes that the way the texts are structured reveal deep-rooted sexist tendencies, from the way most of the films centre on male protagonists, whose status and progress in the films narratives

is dependent on using and/or abusing women. This misogyny was recognised by some critics at the time and placed within a wider cultural context. For example, Penelope Gilliat was prompted to comment on this after viewing John Schlesinger's *A Kind of Loving* (1962):

> The sad thing is that with an ounce more courage it could have been a genuine, affronting original: for if it had the candour to say so its real theme is not social discontent ... but the misogyny that has been simmering under the surface of half the interesting plays and films since 1956. (Gilliat in Hill 1983: 304–5)

There are two types of women in these films: wives and mothers (or potential wives and mothers), and lovers and mistresses (or potential lovers and mistresses). Social and cultural changes wrought during World War Two (women working for the war effort, coping on their own, the rise in divorce rates, and births outside of marriage) it is argued, led to a crisis of masculinity. The cultural response was repressive, and can be seen as attempting to reconstitute gender divisions as if the war never happened. This 'back to basics' repression is evident in fashion, in women's magazines, and in cinema of the period. For all their progressiveness, the British New Wave directors reflected and reinforced this ideological project. (For further discussions see Harper (2000); Geraghty (2001).) Few films in this cycle transcend these category types, or focus on a female protagonist.

In recent years, criticism of the British New Wave working class realist films has also focused on the representation of class. Film historians and theorists have observed that despite the films taking working class characters and settings as their main focus, these films actually work to suppress class inequalities. They argue that by centring so tightly on a single (male) protagonist and his or her struggles, the possibility of collective action and expression is undermined. Social issues are reduced to the micro level of character, rather than explored at the macro level of the social. The films play down class inequalities, choosing instead to promote what Hill describes as an 'accentuated individualism' (1986: 143).

In essence, then, while the films appear to be about class, the excessive subjectivism and its 'privatising effect' on social problems, actually works to suppress issues of class inequalities. In this way, Colin's

downfall in *Loneliness of the Long Distance Runner,* for example, is partly attributed to environmental factors (absent father, disinterested mother), and partly to his stubborn individualism, and not because of social stratification and its subsequent social inequalities. The film is about Colin's struggles, not primarily working class struggles in industrialised, capitalist nations. This can be seen to varying degrees in the majority of the social realist films of the British New Wave. In addition, rather than questioning class inequalities these films appear to advocate that escape from the working class is the only viable solution.

It has been observed that the British New Wave cycle of social realist films, despite their reputation at the time for sexual content (many were given 'X' ratings and played up to them in their advertising), were somewhat conservative. Charles Barr (1986) has noted that this repression of desire is a key element of films of the period, and the working class realist films of the British New Wave are certainly no exception. Moreover, 'A large part of the realism of both New Wave films and the plays and novels on which they were based, lay in the way that they were seen to break taboos around certain subjects, notably sex' (Lacey 1995: 183).

For all the lure and promise of sexually explicit content, the films tend to favour conservative resolutions, which were remarkably consistent with the ideological values and assumptions of the period though it should perhaps be noted that this conservatism should be seen in the context of the prevailing system of film censorship at the time. So, in these films settling down 'ruins' sex, but eventually one must settle down; certain types of women are 'for marriage', others are 'for sex and fun'; sexual experimentation is ultimately empty and meaningless, and heterosexuality – and the gender divides that come with the whole package – is the norm, the ideal: there are no viable alternatives offered. Indeed, when the majority of these films were made, homosexuality was illegal until the law changed in 1967 – ten years after the Wolfenden Report had recommended its partial decriminalisation. There are a few examples of films which attempt to offer or at least explore alternatives including *The L-Shaped Room* (1962), *A Taste of Honey* (1961), *The Leather Boys* (1963).

The claims to realism of these social realist texts through the increased interest in, and portrayal of, sexual activity do reflect changing attitudes towards sex and sexuality in the era of the so-called (if somewhat mythical) permissive society.

Social problems and kitchen sinks

We can sum up this discussion of social problem films and the work of the Free Cinema directors and the British New Wave by making some points of comparison and contrast.

It could be argued that social problem films were more concerned with content issues, more preoccupied by the message than the medium. By contrast, the realism of the British New Wave films centred on the medium and its form – a poetic realism as part of a poetic cinema. Moreover, there is a distinction, too, in the function of each as perceived by the film-makers: the social problem film's function was more socio-logical, whilst the British New Wave directors were excited by the potential of film as art. As we have seen, this distinction existed in the documentary movement. It seems the question of British social realism and its varying forms and styles turns on Grierson's statement about the creative interpretation of actuality, and the way this statement has either directly or indirectly, consciously or unconsciously, been interpreted by subsequent film-makers.

Despite the differences, the two strands have areas of commonality. First and foremost, both clearly attempt to formulate, construct, and engage in dialogue about 'life as it is' and as such can be described as social realist texts. As a result both are open to criticism, not just in terms of the version of reality they construct, but also as part of a realist project or preoccupation.

A second area of similarity between the British New Wave films and social problem films is the way both, to varying degrees, obfuscate class inequalities. Social problem films certainly foreground class in terms of characters and stories, but the 'problems' overwhelm the texts and become so tightly focused upon them and their resolution that class fades into the background. The New Wave working class realist films, on the other hand, focus so tightly on individual protagonists, against a poetic treatment of locations, that class is also lost in the mix.

Thirdly, both strands of social realist film exhibit a marked sexual conservatism in their treatment of sexual and relationship issues, not so much pushing back boundaries as has been claimed but, rather, re-defining limits and re-setting boundaries.

Clearly, both strands of social realist cinema can be seen as contesting, re-drawing, and redefining the issues, representation and treatment of

contemporary society on film. In their favour is the popularising of fictions of everyday life, extending cinema's range of issues, characters, stories and settings. After the collapse of the British film industry in the late 1960s, the social realist project took to the small screen (although elements of social realist style, technique and practice are evident across a diverse range of genre films throughout the 1970s). Social realism's assimilation into the television schedules had already begun with *Coronation Street* (1960), continuing with such landmarks as *Cathy Come Home* and *Up the Junction*. Television, it will be argued, from this point, became the 'natural home' of British social realism and sustained it throughout the hard times ahead in the following decades. As Hallam and Marshment state, the British New Wave was to be hugely influential in television drama and film in the coming decades. They left a 'legacy' which was 'kept alive in British television drama throughout the 1960s and 1970s, re-emerges in some of the films produced by Channel 4 in the 1980s and 1990s' (Hallam & Marshment 2000: 51).

Television drama and social realism in the 1960s

After the 'breaking' of the New Wave, social realism continued in television in the form of 'serious' dramas and the soap opera *Coronation Street*. Serious dramas were often spoken of in terms of quality programming. They were considered 'serious' because they engaged with social issues and contained representations of down-trodden or marginalised groups. 'Serious' dramas challenged accepted notions and conventional representations. Leading figures in television drama, like those of the documentary movement in the 1930s, and the Free Cinema film-makers of the 1950s, had in mind a different role for their medium in society. This role was seen as complementing the public service broadcasting ethos. Sydney Newman, for example, who produced *Armchair Theatre* for ABC before going on to the BBC to produce the influential *Wednesday Play* strands said of his work on serious dramas: 'I am proud that I played some part in the recognition that the working man was a fit subject for drama, and not just a foil in a play on middle class manners' (Newman in Millington & Nels 1986: 11–12).

The 'serious' dramas of the 1960s *Wednesday Play* strand are most often associated with Ken Loach and producer Tony Garnett; notably the drama-documentaries *Up the Junction* and *Cathy Come Home*.

Drama-documentaries were not new to British television (nor to British culture as evidenced in the work of the documentary movement, in Joan Littlewood's Theatre Workshop and in Ewan McColl's radio plays). Drama-documentaries were produced on diverse subjects increasingly from the late 1940s. But Loach and Garnett's work emerged at a time already sensitive to left-wing ideas and already familiar with social realist concerns. What was different about *Up the Junction* and *Cathy Come Home* was how the programmes became 'events' in their own right: 'Within the social space of television, within the politics of its institutions, and within the way it circulates, television programmes have the capacity to be events as much as texts' (Caughie in Tulloch 1998: 124).

The significance of seeing texts as events is that they therefore have a concrete impact on society. Certainly, homelessness was not eradicated overnight after *Cathy Come Home*, but a number of material effects can be observed, from the heightened awareness of the issue in the press and the public sphere, through to the subsequent changes in British social work, and the setting up of the charity, Shelter. For Loach, however, *Cathy Come Home* was not an influential film from a political perspective because it failed to address the structural and economic causes of homelessness, such as who owns the land and who runs the construction industry (see Fuller 1998).

Working in television was not considered a problem by many of those involved in the production of serious dramas. Playwright Trevor Griffiths relished the idea of addressing television's socially diverse audience: 'It's just thunderingly exciting to be able to talk to large numbers of people in the working class and I just can't understand why more people don't do it' (Griffiths in Millington and Nels 1986: 17).

Social realism found new forms, new supporters, and new audiences in British television. Nearly twenty years passed before another politically charged moment would re-emerge in the schedules.

Case study: Saturday Night and Sunday Morning

Made by Woodfall Films on a tiny budget – £117,000[4] – *Saturday Night and Sunday Morning* was adapted from Alan Sillitoe's novel of the same name which had attracted much interest from the left-wing intelligentsia in Britain. But as Robert Murphy (1992) points out, whilst Sillitoe had much in common with other Northern-based writers focusing on working

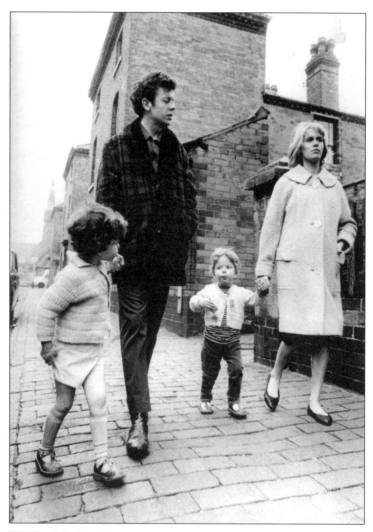

FIGURE 3 *Cathy Come Home*

class characters and their lives (Keith Waterhouse, David Storey), the
circumstances of the novel's birth could not be farther from the industrial

North. After being pensioned out of the RAF on medical grounds, Sillitoe moved to the warmer climes of Majorca where, according to Murphy, the author began work on it in the shade of an orange tree. Reisz was persuaded to direct a film based around the novel and though critics were initially disproving of the central protagonist's lack of a moral compass, they were intrigued by what appeared to be the representation of a new archetype evolving in post-war British society. The film was an unprecedented success with audiences: in only three weeks of doing the rounds in London cinemas the film had grossed in excess of £100,000, the first film to achieve this magic figure (see Murphy 1992).

The film centres on Arthur Seaton – an archetypal angry young man – pursuing his pleasures after clocking-off time at the factory. His womanising, drinking and brawling make him a difficult protagonist to sympathise with, and yet in spite of his voice-over's insistence that he won't be ground down by the bosses or women, by the end of the film he has somewhat reluctantly given in to the system. As he stands on the hill looking down towards the new houses being built with his fiancée, Doreen, he seems compelled to hurl stones in the direction of his future home. This can be read in a number of ways: as a sign of Arthur's continuing struggle against settling down and mediocrity (Sillitoe's preferred interpretation), as a sign of his frustration at the futility of his struggle against work and domesticity (Reisz's view), or as the act of a boy resisting manhood who needs to be told off for throwing stones by his mother/fiancée (Murphy 1992: 20–1.)

Despite being independently produced by Woodfall the film's meagre finances were put up by Balcon's Bryanston consortium. However, the success of *Saturday Night and Sunday Morning* gave Woodfall some degree of financial security, which in turn enabled the film-makers to exercise greater freedom in terms of the films they chose to produce and the practices employed in making them. This was only partially achieved in *Saturday Night and Sunday Morning*. Some of the scenes are shot on location, but it is by and large a studio-based film.

Costs of *Saturday Night and Sunday Morning* were kept down, largely due to another aspect of the film-makers' practice, which was in turn informed by their social and political intent. The film's cast was made up of actors from the stage unknown to British cinema screens. Albert Finney (Arthur Seaton) had made a name for himself playing the lead in *Billy*

Liar in the theatre, and had featured in a cameo role in the unsuccessful Woodfall feature, *The Entertainer (1960)*. Rachel Roberts (Brenda) was also known as a stage actress. Meanwhile, the film was the feature debut for such stalwarts of British screen culture as Colin Blakely, Bryan Pringle, and Hylda Baker. Shirley Ann Field (Doreen) was the only member of the cast who might be seen as an experienced screen actor. This use of relatively new talent with regional accents was part of the New Wave's commitment to social extension.

These representations connect with the themes and issues explored and included in this moment of social realist cinema in Britain. As we saw at the beginning of this chapter, a central preoccupation with critics and social commentators on the left and right of the political spectrum was social change, and with the new formations and 'characters' these social changes were generating. In crude terms, critics to the political right were concerned with the perceived social and sexual amorality of the working classes – particularly working class youth. On the left, commentators were concerned with what they perceived to be a threat to traditional working class culture, although this concern had been voiced in the 1930s – by writers like George Orwell, for example – who predicted that the downward slide of middle class culture into popular culture was imminent. Some believed Americanisation was the causal factor in this process, whilst others attributed it to the rise of consumerism. Both, to varying degrees, were seen to have a corrosive effect on traditional working class culture. The working class realist films of the British New Wave reflect these concerns and *Saturday Night and Sunday Morning* is no exception. And yet as with the other working class realist films of the period, their view of the working class is highly ambivalent. In *Saturday Night and Sunday Morning*, Arthur's father, the representative of the traditional working class male, has been lulled into a television-induced coma. We do not see him at work, only in a domestic setting.

The forces of consumerism, on the other hand, are associated with women. For example, in the final scene, Doreen tells Arthur she wants a new house with new fixtures and fittings. The implication is that his life of toil in the factory will keep Doreen in the lifestyle she aspires to. As Murphy states:

Women in the kitchen sink films suffer interminably. Brenda (Rachel Roberts) is a willing partner in her sexual liaison with

Arthur, but when it comes to the consequences the price she has to
pay is immeasurably greater. (1992: 33)

In terms of class consciousness, *Saturday Night and Sunday Morning*
offers neither solutions nor enlightenment. Rather, its focus on the
individual Angry Young Man figure excludes the possibilities of unified
class action. By reducing the struggles of a new breed of working
class youth to the angst of one rugged individualist the film succeeds
in negating the issue of class altogether. Arthur's dissatisfaction, as
Andrew Higson (1996) notes, works to obscure class tensions, displacing
them onto generational differences. Much of Arthur's vitriol is directed
towards his older co-workers and, indeed, his lack of respect for Robbo
(Bryan Pringle) is justification – if not the real reason – for having an
affair with his wife. It could also be argued that the moral realism of the
film dictates that by its resolution Arthur will have, to some degree, been
cowed by those he has derided, and by the system. It may not be passive
acceptance of his fate, but acceptance it certainly is nevertheless.

In terms of style and form, *Saturday Night and Sunday Morning* has
many of the features we would now see as part of the lexicon of British
social realist texts. Indeed, many of the stylistic and iconographic
conventions developed during this moment of social realist film-making
are the staples of the social realist repertoire today. Despite Reisz's plain
aesthetic a number of the features outlined in the above discussion are
present. A familiar iconography – cobbled streets, factory chimneys, spit
and sawdust pubs, oily canals, the shots of the townscape, especially
'That Shot of Our Town From That Hill'. The naturalist convention of
setting acting as a metaphor for the states of minds and the situations
of protagonists is used in the text. For example, when Brenda tells Arthur
she is pregnant they are secreted away above the city, the wind whistling
through their dialogue underlining their stark and serious situation.
Another example of this can be found when Brenda and Arthur try to
escape from the soldiers pursuing them by taking a fairground ride. Their
genuine anxiety stands in stark contrast to the pleasurable screams and
thrills of the other patrons on the ride. Reisz's style in *Saturday Night and
Sunday Morning* has been described as an 'anti-style':

The camera does only enough work to tell the story as simply and
directly as possible. Because of this the audience is encouraged to

FIGURE 5 *Saturday Night and Sunday Morning*

make judgements for itself. Very few contemporary films, whatever their quality, leave their audiences alone. (Lovell in Murphy 1992: 19)

The tension between realism and poetry is evident in *Saturday Night and Sunday Morning*. The paradoxical spectacle of beautiful ugliness, the man in the man-made environment, serves to disrupt and halt the process of narration. There are sequences of high-angled shots of the city. For example, the morning after Arthur's beating in the back streets, we have several shots of the city – various shots of the townscape taking in the factory, the freight trains, and into the neighbourhood where Arthur lives and eventually into Arthur's bedroom as he wakes bruised and battered. These shots serve to frustrate the action, slowing down the narrative's progress towards resolution and solving the immediate enigma of what happened to Arthur after the attack. At the same time, this sequence offers a visual spectacle to the spectator which serves to

distance them from the narrative and Arthur's plight. Arthur is a son of the city, made for and by it, and these shots of the townscape emphasise this. Arthur, like the city, is to be at various moments observed and studied as part of, and contained by, it. As the camera and the spectator scan the skyline we are perhaps reminded that Arthur's is but one story in this compact working class community. This works against the grain of classical Hollywood realism where audiences are encouraged to identify or ally themselves with one central protagonist throughout the course of the narrative. Consequently, the narrative distance these sequences of the townscape offer in the kitchen sink films of the 1950s and 1960s counteract the tightly focused narrative drive of classical realism. The film has a fairly conventional narrative form, the camera predominantly works to provide a seamless sense of viewing a 'slice of life' in that it is largely 'invisible' in the text so the distancing effect of the townscape and landscape sequences also comments on the position of Reisz and his imagined audience with regards to the view of the working class and the industrial landscape. As Higson notes, it is only outside of the city and its problems that industrial romanticism can be a viable aesthetic. Furthermore, this aesthetic works in much the same way as that of the Unknown England texts of the nineteenth century and the Griersonian documentaries of the 1930s and 1940s: the masses can be transfigured into 'the working class' who, like all human beings, have hopes, fears, dreams and principles.

Showing the concrete and cobbled jungles of the industrial North and the natives who inhabit them to the middle and upper classes renders them safe and knowable, and identification with individual working class characters encourages in the spectator a tendency to see people as people rather than as members of distinct class. In short, films like *Saturday Night and Sunday Morning* do not explore the exploitation of the working class. Rather, social inequalities are displaced to such a degree that the 'problems' represented are 'universal problems' that could happen to anyone, regardless of class. If there are sites of conflict and difference in the film they are not between the factory's trade union and the factory owners, the 'haves' and the 'have nots' in society. The conflicts represented in *Saturday Night and Sunday Morning* are intra-class relations, like the tensions between new and traditional working class culture (represented in the relationship between Arthur and his father), or between men who are cuckolds and men who aid wives to

cuckold their husbands (as in the relationship between Arthur and Robbo). Of course, by focusing on such relationships the possibilities of the film championing the working class and working class culture are undermined, because the social problems explored are framed in terms of personal, not economic or industrial relations. Thus, in spite of its oppositional perspective on industrial labour, the progressive nature of *Saturday Night and Sunday Morning* fails to go much further than extending the representational vocabulary of British cinema.

In the following decades British social realism as a mode of expression remained influential. But it was in the 1980s against the social, political and economic backdrop of Thatcherism that it fully rediscovered its political dimension, and it is the 1970s and 1980s that we now turn to in the next chapter.

5 1970S AND 1980S: TOWARDS A SOCIAL ART CINEMA

The 1970s were a difficult period for British cinema – with the withdrawal of American finance at the end of the 1960s, the industry was in near collapse. Some directors were fortunate enough to continue working in films, albeit in America, whilst others worked in television or in theatre. With no industrial structure and only limited government support through the Eady Levy and the National Film Funding Corporation, the up-and-coming directors honed their talents in television or advertising. At the same time, the post-1968 interest in avant garde and experimental film provided social comment in film, although as is characteristic of art cinema and the avant garde, that social comment tended to be reduced to individual experience, or to the level of the personal and psychological, rather than the public and the social. Social comment could also be found in British genre films, most notably in the horror and crime genres.

The BBC and Independent Television (ITV) companies were producing films and dramas for television, while the film industry concentrated on making film versions of television sitcoms (for example, *On the Buses* (1969–73), *Love Thy Neighbour* (1972–76), *The Likely Lads* (1964–66), *Bless This House* (1971–76), and *George and Mildred* (1976–79)). Hammer horror films and the *Carry On* cycle were also popular with audiences. Ken Loach was almost single-handedly responsible for sustaining social realist texts in British screen culture, producing some of his best and most hard-hitting films and television dramas from the late 1960s to the early 1970s (films: *Poor Cow* (1967)), *Kes* (1969), *Family Life* (1971); television dramas: *The Rank and File* for BBC's *Play For Today* (1971), *Days of*

Hope, a four-part drama for the BBC (1975), and *The Price of Coal* (1977), a two-part drama for BBC's *Play For Today*).

With the setting up of Channel 4 in 1982, the fortunes of the British film industry changed. This meant gains and losses to British film culture. The 1980s, too, saw a renewed interest in social realism, with many liberally-minded artists, performers, directors, and writers expressing deep dismay at the perceived changes wrought by Thatcherism and the repressive, materialistic culture it produced.

All of these factors shaped the industry in Britain: what kinds of films were made, how they were exhibited, who made them, and the content and representational issues they contained.

Film and television: a 'delicate ecology'

It has been observed that after American companies pulled out of Britain at the end of the 1960s, closing their UK-based studios, the industry collapsed because it had failed to enmesh itself with the television companies, as was the case in some other countries whose production levels were maintained (Italy is a notable example). By the mid-1970s the government had begun to listen to film-makers and producers and intervened, formulating and passing the Cinematograph Act 1974, 1976. The first Act set up the National Film Funding Corporation, which would filter money in the form of loans (already known as Eady money after Sir Wilfred Eady, the senior Treasury Official who developed the policy) to selected British film-makers. The 1976 Act extended the NFFC's discretion in lengthening the repayment period of loans.

The NFFC was not a major success. For example, in 1979 only 45 feature films were made and released, although all but one received theatrical release (see Murphy 2000). In 1982, Channel 4 began broadcasting. Set up after recommendations in the Annan Report 1977, Channel 4's remit was to provide viewing for minorities and to represent hitherto under-represented groups in society. Despite its 1980s birth-date, the inception of Channel 4 was very much part of a pre-Thatcher era.

Channel 4 was also committed to feature film-making through its commissioning of new British films, as part of its Film on Four series (and later, film financing through Film Four International). It has been argued that by tying film production to British television – traditionally a public service system – a kind of public service cinema emerged (see Giles

1993; Nichols 2001). Channel 4 also supported various film and video workshops and collectives across the UK.

Channel 4's film policy had been based on the German public service broadcasting model of film financing during the late 1970s and early 1980s. The German model is seen as having played a major role in the development of New German Cinema in the same period. Channel 4 saw itself as a 'publishing house' (Giles 1993: 66) rather than as a producer of films and this is the most significant difference between the organisation and the BBC and ITV companies. Part of their remit was also to commission a proportion of new works from independent production companies and the Film on Four series helped them fulfil this to a large extent. Channel 4 is often cited as a major contributor to the so-called (and somewhat previous) renaissance in British cinema.

For John Hill, this period led to the establishment of a 'delicate ecology' between film and television that would deliver both gains and losses to British film culture (1986: 63). Giles (1993) is in agreement with this point and notes that Channel 4 institutionalised the close relationship which had developed between television and film production during the seventies.

Channel 4 television films addressed minority audiences, and by and large represented the under-represented thus extending the subjects and representations in British film culture. The channel gave television directors such as Stephen Frears the opportunity to develop their work (from Channel 4 films like *Bloody Kids* (1979), *My Beautiful Laundrette* (1985), *Sammy and Rosie Get Laid* (1987), *Saigon: Year of the Cat* (1987), to America, where he directed films like *The Grifters* (1989), *Dangerous Liaisons* (1990), *Hi Fidelity* (2000)). Channel 4 also gave more experimental film-makers like Peter Greenaway the opportunity to reach a national audience with such films as *The Draughtsman's Contract* (1982), *The Cook, The Thief, His Wife and Her Lover* (1989), and *Baby of Macon* (1993).

Furthermore, playwrights and film-makers appreciated large audiences, seeing a Channel 4 commission as an opportunity to 'speak to the nation'. Stephen Frears wanted as many people to see his work as possible, and to be talking about it afterwards, whilst Alan Bennett saw it as an opportunity to 'address the nation'. This certainly strengthens the claim that Channel 4's films can be regarded as a kind of public service cinema.

FIGURE 5 *My Beautiful Laundrette*

There is little doubt that Channel 4 invigorated the British film industry during the 1980s. However, there were certain prices to be paid for this. First, although many more films were made – between 1981 and 1990 Channel 4 partially funded 170 feature films (see Hartog 1983), proportionally fewer made a theatrical release. This, however, should be weighed against some films which did well at the box office and were given theatrical release prior to the television screening (*The Ploughman's Lunch* (1983), *The Draughtsman's Contract*, *My Beautiful Laundrette*). While the films rarely made substantial profits, they did have an advance promotional effect, attracting greater numbers to the television premieres as well as gaining overseas sales and attracting investment (see Nichols 2001).

Second, despite public service claims, there was also an economic imperative, and this influenced the way Channel 4 financed films later in the decade. As Giles (1993) has noted, from 1984, after a number of commercial failures on the cinema circuits, the organisation reduced the amount of films it funded in its entirety, choosing instead to co-fund with organisations like the doomed Goldcrest Company and the privatised version of the NFFC, British Screen International.

Third, the television films were seen by some within the industry as unambitious, unimaginative, diluting 'art' for television audiences. Lindsay Anderson observed that there seemed to be 'a certain restriction of imagination or idea' and the blame lay with the tastes of those commissioning the films at Channel 4. This, he argued had an impact on the aesthetic qualities of film as 'cinema', arguing that 'if you make a film for television, you have to restrict it in terms of technique or style' (Anderson in Nichols 2001: 66). Derek Jarman was more characteristically pithy in his condemnation, stating that Channel 4 films were what the '"Television Men" wanted in order to complement the ads' (Jarman in Nichols 2001: 66).

Thatcherism and the British film industry

In order to understand British film-making of this period and the renewed interest in social realism in the 1980s, it is crucial to understand the social, political, and economic climates and their impact on an already ailing British film industry.

Emerging as a nation weary of strikes and shortages under the Labour government of James Callaghan at the end of the 1970s, the Conservative Party chose a sharp, shrill Cambridge chemistry graduate and former Minister for Education as their leader – Britain's first, and so far only, female Prime Minister. Margaret Thatcher's administration was characterised by repressive, backward-looking social policy coupled with a laissez-faire economic approach. Peter Wollen sums up Thatcherism as comprised of three distinct elements: a light touch neo-liberalism with minimum state intervention, a neo-conservative authoritarianism, and a social project centring on dividing the nation between the poorer, industrial North, and the affluent, metropolitan South (1993: 35).

Consequences of this new political philosophy included mass unemployment (4 million at its peak), privatisation of nationalised public utilities (telephone, gas, electricity, water, rail transport, for example), and a substantial weakening of trades unions through binding legislation. Furthermore, Thatcherism had a moral crusade, to weed out and punish the 'workshy', to encourage materialism, to re-establish the family whilst at the same time introducing repressive legislation to 'outlaw' those lifestyles and pursuits which contradicted Thatcherite ideology (gay men and women, single mothers, trades union activists, and later travellers,

ravers and demonstrators). The social and political context proved to be a spur to many working in the arts, and the early to mid-1980s saw a general shift to more left-field politics, and if not completely socially committed, at least socially aware. There can be discerned a return to social realism in the arts after a decade of experimentalism and anti-realism.

In film, Chris Bernard, Stephen Frears, Mike Leigh, and Ken Loach all made films in a social realist vein. On television, more 'gritty' British soap operas were introduced – *Brookside*, *EastEnders*, *Albion Market* – to counter the 1980s excesses of glitzy continuous serials like *Dallas*, *Dynasty*, *Falcon Crest*, *Flamingo Road*, *The Colbys*, and *Knot's Landing*. Dramas such as *Boys From the Blackstuff*, *Auf Wiedersehen Pet*, and *Prospects*, sat uncomfortably alongside mainstream products like *The Thorn Birds*, *Lovejoy*, and *North and South*. In sitcoms, working class characters and the pathos of their social situations were common and highly popular – for example, *Only Fools and Horses*, *Birds of a Feather*, and *Going Straight*. Alongside these more conventional comedies sat the new 'alternative comedy' of *The Young Ones*, which explicitly attacked Thatcherism and materialism whilst at the same time poking fun at political correctness. In music, bands popular with the new disaffected youth, who had Youth Training Schemes (YTS) to look forward to upon leaving school, made quite specific social comment and still charted – for example, 'Ghost Town' by The Specials, and 'One in Ten' by UB40. Indeed, Jerry Dammers of The Specials wrote 'Ghost Town' in response to witnessing the decimation of their young audiences as they toured Britain at the start of the 1980s. In children's television, *Grange Hill* was proving popular among teenagers and dealt with controversial personal and social issues often articulated through the representation of inequalities in gender, class and ethnicity. The programme was written and produced by Phil Redmond, who also produced *Brookside*. *Grange Hill* regularly became the focus of the often angry attentions of the tabloid press. It's spin-off series *Tucker's Luck* also engaged with social, economic and political issues usually within a domestic or local context. Later, *Byker Grove* would continue the tradition, only shifting emphasis away from the South to a Newcastle youth club. There were even attempts in the mid- to late 1980s to band artists together under the banner of 'Red Wedge', offering an alternative discourse to the dominant Thatcherite ideology.

The film industry in Britain certainly did not find a friend in the Thatcher administrations. John Hill sums up the Conservative government's policy

stance as one of 'aggressive non-intervention' (1996: 117) and it is clear Thatcher's governments saw cinema as a commercial enterprise which would need to sink or swim on its own.

Dystopia to the dole

As Hill has observed, moments of realism are never solely concerned with the aesthetic representation of the real, but are actually bound up with specific ways of bringing to the fore the issues and concerns that are perceived to be 'contemporary reality' (2000b: 250). This means social realist films will reflect and amplify issues and concerns affecting society as perceived by socially conscious film-makers. As we have seen, these concerns are characteristically bound up with representations of the working class in British social realist texts. Thus a range of film-makers chose to articulate their fears and concerns for the state of Britain in the 1980s. Whilst not a social realist film-maker, Derek Jarman's dystopic visions of a morally bankrupt Britain contained social realist elements in response to prevailing social conditions (see *Jubilee* (1978) and *The Last of England* (1987)). Dystopias with a realist – or 'social surrealist' – edge were also to be found in films like *Britannia Hospital* (1982) and *1984* (1984).

Those working in the social realist mode responded to the effects of Thatcherism in their thematic concerns. Given the administration's agenda it is undeniable that film-makers such as Ken Loach, Stephen Frears and Mike Leigh saw their films as not mere critiques of Thatcherism, but rather full-blown cinematic or televisual attacks on its policies. Ken Loach worked mainly on documentaries during the 1980s. Fuller notes:

> Loach was convinced that the only way to confront the crisis in the British trade union movement that greeted the Thatcher government's draconian policies was to make not fiction films but documentaries. (1998: 63)

For Loach making fiction films at a time of national crisis seemed unacceptable:

> The idea of making a feature film which took three years to finance and another year to come out and then got shown in an art house to

ten people and a dog just seemed a crazy thing for me to be doing.
(Loach in Fuller 1998: 64)

Stephen Frears, on the other hand, chose the feature film to attack
Thatcherism, claiming that his film *Sammy and Rosie Get Laid* was
intended to bring down the government (see Hacker and Price 1991). Mike
Leigh's 'heightened realism' or 'social surrealism' articulated its concerns
in films like *Meantime* (1983) and *High Hopes* (1988) by mounting a
critique in a low-key style through close character identification with a
sharp focus on the effects of Thatcher's Britain on inter-personal rela-
tionships.

The issues such film-makers were concentrating on reveals the
extent to which they were responding to the framework of policies of
the Conservative government. Youth unemployment was a key theme
explored in films such as *Looks and Smiles* (1981), *Made in Britain* (1982),
and *Letter to Breshnev* (1985).

There is a centring on youth unemployment as 'social problem', played
out not in class terms but in such a way as to reduce the class issue down
to a concentration on an individual protagonist. This tends to mean
that resolutions centre on the escape, whether successful or not, of an
individual rather than offering any prospects for collective class action
or resistance. This is a trend which, as we have already seen, was estab-
lished in the social realist films of the British New Wave. The concentra-
tion on youth in many of these texts reflects the growing concern about
youth unemployment in the 1980s and the lack of prospects for young
people after leaving school. The Conservatives' answer to this was the
YTS programme, which offered unemployed school leavers temporary
work placements. This amounted to a full week's work for an extra £10
per week on top of benefits (a parent of the New Labour government's
New Deal scheme). For many this seemed like exploitation, allowing
businesses already receiving a raft of concessions, inducements and
tax breaks under the Conservative administration to fill their workforce
with underpaid young people. Often promises of full-time employment
on full pay at the end of the scheme would be made by employers only
to be reneged upon once the placement was over. Another YTS scheme
participant would simply take the place.

It is perhaps worth noting that, given the increasing importance of
box-office receipts and ratings, that more films aimed at or about young

people, with photogenic 'up-and-coming' young talent (Gary Oldman, Tim Roth, Margi Clarke, Alfred Molina) were being made or were seen to be more viable.

Another trend established by the British New Wave films of the 1950s and 1960s, which continued in the 1980s social realist films was an increasing concentration on the sphere of the domestic and the family setting. It is particularly pronounced, however, in the 1980s and is a trend which continued into the 1990s and beyond. Andrew Higson's assertion that a key characteristic of British social realist texts is the 'changing conceptualisation of the relation between the public and the private ... the political and the personal' (Higson in Barr 1986: 83) seems to be verified in the 1980s. Social issues are explored through familial and personal relations, although part of the justification of this in the 1980s would be the distinct lack of work available to protagonists in the worlds of the films to take them outside of the home. Furthermore, this informs another key shift identified by Julia Hallam (2000), namely the move towards defining the working class experience through specific patterns of consumption rather than as workers.

In the 1980s, less focus is placed on dysfunctional families than would be seen in the social realist texts of the following decade, although clearly, in many of the films, family dysfunction is evident but not fore-grounded. In many social realist texts of the period there is an absence of family rather than a focus on the effects of a troubled family, although it could be argued that the absence of family in such cases is posited as the central problem, which is in itself an effect stemming from familial associations. From prison dramas like *Scum* (1979) to more conventional social realist texts like *Made in Britain* and *Rhino* (1988) the family is to varying degrees replaced by the institutional juvenile care system. Texts principally concerned with youth tend to focus on inter-personal relation-ships and particularly the expression of sexuality and it is here many social conflicts are played out (*My Beautiful Laundrette*; *Sammy and Rosie Get Laid*; *Rita, Sue and Bob, Too*; *Career Girls*; *Meantime*; *Letter to Brezhnev*, and to a degree, both *Scum* and *Scrubbers* (1983)). This again demonstrates how social realist texts are tied to the specific moments of their creation. Throughout the 1980s, the Thatcher government spear-headed many a moral panic relating to the sexuality of young people, from teenage pregnancy and single-parenthood to the sustained attack on the gay community and their lifestyles in the era of AIDS.

Despite Britain's increasingly multicultural community, few social realist texts dealt with the issue of racism and racial inequality, despite riots in the early 1980s in Brixton and Broadwater Farm in London and Toxteth in Liverpool. The documentary *Handsworth Songs* (1986), television feature *Rhino* and Frear's feature *My Beautiful Laundrette*, are notable exceptions, although in the latter two instances the ethnic identity of the central protagonists is used only to further signify their difference and the 'problems' associated with that difference. Racism, institutional or otherwise, is rarely explored in depth. Clearly, the social extension impulse of social realist film and programme makers in the 1980s had yet to ripple out to include minority cultures in Thatcher's Britain.

Pushing the boundaries of social extension

Whilst the British social realist texts of the 1980s did little to extend the range of representation in the direction of Britain's ethnic minorities, there was one area where a major shift took place – the representation of women. As we have seen in the previous chapter, one of the failings of the films of the British New Wave films was their misogynist tendencies. With only a handful of exceptions, the protagonists in the 1950s and 1960s films were young men. Women were both objects of desire and derision. In the 1980s, this failing is addressed with some success, extending the range of representation in line with the extensionist urge of social realism to include strong female protagonists. Such characters are frequently counter-posed with weak, socially impotent men who are more often than not, unemployed. Thus, it could be argued that these films suggest that the increased social position of women has been bought at the expense of men and male working class communities. However, it can be argued that in the majority of the films centring on female protagonists it is their sexual power rather than their social or economic power which raises them above the male characters. In the 1980s social realist texts we see a proto-type girl power emerging which would help sow the seeds of 'ladette' culture in the 1990s. Women are in control of their own identities but these identities are still very much dependent on love and relationships rather than careers, aims and goals. Where aims and goals are specifically part of the story these female protagonists are no different to their male counterparts of the 1950s and 1960s for they revolve around a need to escape the drabness of their working class surroundings rather

than bettering the lot of their socio-economic group. The female characters in Mike Leigh's films, however, bear certain similarities to the way women were portrayed in the New Wave films of the 1950s and 1960s. For example, Hill (1999) points out how the character of Valerie in *High Hopes* is similar to a certain kind of representation found in the films of the British New Wave. This character type, according to Hill,

> harks back to the tradition of British working class realism of the 1960s ... which not only criticised the 'corruption' of the working class by consumerism but characteristically associated superficiality and an 'excessive' interest in acquisitions with women characters – who were then symbolically 'punished' for their apparent threat to 'authentic' working class masculinity and male virility. (1999: 194)

Thus Hill argues that the theme of the demise of the traditional working class first fore-grounded in the British New Wave films of the 1950s and 1960s is evident in the social realist texts of the 1980s. He later notes that there are two approaches taken to emphasise this demise in representational terms. First, a new social archetype emerges whose purest form can be seen in the Harry Enfield character 'Loadsamoney'. This archetype was solely directed towards the possession of goods and the accumulation of wealth, with little concern as to how it was acquired or the impact of their activities on others. Rather than identifying with Labour politics, this group were new Tories and a vital group for the Conservative Party to win over to ensure General Election victory. This new character type – rarely portrayed sympathetically – is offered as both evidence for, and critique of, the fragmentation and collapse of the traditional working class. And whilst this process had been ongoing since the post-war era, Thatcherism was responsible for its acceleration (see Hill 2000b).

The second representational approach which expresses concerns over the demise of the traditional working class in Britain can be traced back to the documentaries of the 1930s: the portrayal of the working class as victims. In the 1980s the harsh economic realities of life in Thatcher's Britain were seen as pivotal in destroying working class communities and families, through unemployment and the ever-increasing divide between 'the haves' and 'have nots' in society. But it is not merely affluence that is cause for concern in these films. As Hill notes:

In such films as *Letter to Brezhnev* [and] *Rita, Sue and Bob, Too* …
the decline of this working class 'way of life' is identified not with
affluence or upward mobility but with the collapse of traditional
heavy industries (especially in the North) and the associated expe-
riences of unemployment and poverty. (2000b: 251–2)

The themes and issues and the range of representations to a large
degree continue many of the established conventions and thematic
preoccupations as did the last major realist movement before it. But
as societies change over time, and while there are certain thematic and
representational continuities, the films in the 1980s cannot be under-
stood without considering the social conditions in which these films
were made. What is also important to note is that whilst the Free Cinema
Movement and the subsequent New Wave were at least influenced by, if
not working directly to, a set of stated principles and goals, this is not
true of film-makers in the 1980s. There was little attempt by the prin-
ciple social realist film-makers to respond to Thatcherism collectively
as film-makers (our case study, *Letter to Brezhnev* is one exception, as
is the documentary *Handsworth Songs*, and other texts produced by
film collectives within the Black and Asian Film Movements). Rather,
there was a disparate group of highly individual film-makers, whom by
chance should happen to be responding to Thatcherism by working to
expose or even overthrow it.

Form and style: documentary realism to social surrealism

Whereas in the preceding chapters we have been able to speak in
broad terms about formal and stylistic features, since the 1980s this
has become increasingly difficult. Hill sees the vicissitudes of the
international film markets and the British film and television industries
as playing a part in this:

Whereas the British New Wave still operated within a broadly
commercial system in which directorial authorship was not a
particular selling point, British films since the 1980s have increas-
ingly depended upon a system of production and distribution
characterised by state or television support and more international
and specialised art house exhibition. Such a system has placed

an increasing emphasis on the definition and promotion of British cinema in terms of its directors. (2000b: 255)

As an illustration of the stylistic differences we may compare and contrast the work of Ken Loach and Mike Leigh. In discussing form and style, we are dealing with a disparate range of directors, each with distinctive styles and ways of representing 'life as it is', working in film and television, making documentaries and fiction films, in feature length and short forms. This means it is difficult to speak of 'style' in 1980s social realist texts or indeed, forms of social realism.

Mike Leigh and Ken Loach are often read as having similar stylistic approaches. Both often employ a strategy of filming which articulates a documentary-look whilst picking out nuances of character movement – 'balancing forward movement', and the 'little asides or looks ... that help to describe people' (Loach in Hill 1996:193). Yet there are significant differences. Leigh allows actors freedom to develop their characters and focuses very much on their performances, whereas Loach is known for surprising, even shocking, his actors. As well as these different directorial approaches to performance the directors have different thematic preoccupations – Leigh is interested in family life whereas Loach's concerns are more centred on social and political issues articulated through characters. Leigh has been criticised for constructing characters that are no more than collection of tics and mannerisms which informs his style by focusing in on these details of character to allow them to 'speak' to the spectator. Loach, on the other hand, tends to give his characters more space, relying on long takes and wide shots.

Loach's cinéma vérité style makes his features look like documentaries which activates the social or 'critical realism' (see Knight 1997) and work to differentiate his films from mainstream texts. There is a loosening of the cause/effect chain associated with classical narration so that what we are presented with gives the impression of following the every day life of an ordinary working class person (see Hill 2000b for further discussion of Loach's technique). The use of locations and his habitual use of non-actors also signifies his work's difference to mainstream cinema – something which continues the traditions of film-makers working in the social realist mode from the 1930s to the 1960s. In terms of visual style Loach's documentary 'look' is in sharp contrast to the transparency of classical realism in mainstream cinema. The observational style draws attention to itself.

As Hill puts it, 'The point about this style is that it achieves much of its 'realistic' quality from being noticed' (2000b: 256). Long takes, naturalistic light and sound, and observational long shots all work in concert to create a text which aims to look unreconstructed, 'refusing the seductions of stylisation or the placebos and panaceas of happy endings' (Fuller 1998: ix).

By contrast, Mike Leigh's style has been variously described as 'social surrealism' and 'heightened realism'. Leigh utilises some of the same formal and stylistic strategies as Loach to give a documentary look to his work (loose, episodic narrative structure, and camerawork and editing which does not draw attention to itself beyond recognition in the spectator that the work is not a mainstream product). However, Leigh does have a distinctive authorial style, much of it derived from the way he prefers to work with actors. He is noted for his use of improvisation or 'constructive rehearsals', and it is this which enables Leigh to extract performances from actors who 'become' the characters they portray down to every imagined tic and mannerism. Leigh says of his method: 'All the actors in all my films work with me to create the characters' (Leigh 2000).

So part of Leigh's style evolves from his practice of working with actors to develop their characters in great depth. The subsequent detail is picked up and amplified by the director, which in turn helps to create an intense and personal realism, or 'heightened' realism.

Case study: Letter to Brezhnev

It has been noted that contemporary social realist texts tend towards hybridity of generic form. We might argue that it is in the 1980s where hybridity, as a logic of film form and style, became more prevalent, and this would fit into most discussions of postmodern culture. *Letter to Brezhnev* is a good example of a hybrid film: it is part social realist text, part love story, and part romantic comedy. In terms of practice, the film's makers are just another team of left-field, impoverished cultural workers in a long line of independent artists, trying to bring their work to life in a climate that considers financial rewards more important than talent and ideas. They also share these experiences with film-makers in the social realist tradition in Britain for all, in different ways, have had to negotiate the choppy waters of film finance, distribution, and exhibition without major backing. And yet the makers of *Letter to Brezhnev* can be distinguished from previous generations of film-makers in this area in a

number of ways. Firstly, director Chris Bernard and writer Frank Clarke have little empathy with previous social realist film-makers. Bernard, for example, argued:

> What I find funny about it is we've taken a story that, if Ken Loach had done it, would have been a documentary; but because me and Frank as kids, sat and watched all these movies at the Saturday cinema, we've been influenced by all that Hollywood glamour. (Bernard in Swain 1985: 55)

One of the features of British social realist texts is their difference to the mainstream products offered by Hollywood. And yet in the 1980s it seems a different tack was adopted by film-makers – one of assimilation and adaptation over differentiation, whereby what was interesting and glamorous in Hollywood was taken and transplanted in the form of two ordinary girls from Kirkby.

And yet this film also typifies the way that small British films of the 1980s were being made – on a shoestring with promises of deferred payment to actors and crews. *Monthly Film Bulletin* noted that *Letter to Brezhnev* was about more than two working class girls from the North: 'It is also about how to make a film that is fast-moving, entertaining, funny and poignant, with almost no money and unknown actors. In short, how to make a British film' (Forbes 1985: 310).

The film centres on two friends: Elaine (Alexandra Pigg), who is unemployed, and Teresa (Margi Clarke), who works in a chicken factory and for whom life is about 'drinking vodka, getting fucked and stuffing chickens'. On a night out the two girls scrounge or steal drinks, blag their way into clubs and steal a wallet. They escape into the State Ballroom and meet Peter (Peter Firth) and Sergei (Alfred Molina). The girls pay for a hotel from their ill-gotten gains, and a night of passion ensues for Teresa and Sergei, whereas Elaine and Peter simply talk and compare life in the UK and the USSR. Elaine decides to go to the Soviet Union to start a life with Peter. She writes to Brezhnev – not realising he is dead – asking for his help, and receives a visa and plane tickets to start her new life abroad. Her mother, her community, and the press try to prevent her going. The Foreign Office tries to dissuade her by telling her Peter is married and showing her a picture of him with his wife. Initially Elaine is deterred but Teresa questions the allegations that Peter is married and encourages her

friend to follow her dream of escaping to a new life. The film ends with Elaine heading off through the departure gate bound for Moscow, leaving Teresa at home with her glamorous lifestyle of vodka and sex by night and chickens by day.

Letter to Brezhnev was made by an unemployed group of friends from Liverpool and should be seen, as with all social realist texts, in its context: of Liverpool in the 1980s in Thatcher's Britain. This context was something the film-makers were acutely aware of, as production designer Jonathan Swain states:

> By the time that Mrs Thatcher inherited the reins of power the whole population of Liverpool was on the front pages. Riots, unemploy-ment, doom, gloom and despondency were upon us. Then my mate Frank [Clarke, the writer] shimmied in – time to put our glad rags on and do something. (1985: 53)

The film had, by feature standards, a tiny budget. Beginning with £35,000 given by friends, it eventually reached completion at a budget of £80,000. Swain commented on this achievement: 'What's been produced is a full-length movie for less money than some in the media put up their noses in a week' (1985: 55). What was also significant and a point of particular pride for the film-makers was that they did this outside of the film industry and beyond London and they concluded that they had proved this. For them *Letter to Brezhnev* was 'a film that shows it can be done without being in London, New York or Hollywood' (1985: 55).

The way Bernard, Clarke, Swain and their team produced this film marks them out as independent film-makers. In a move that is reminis-cent of Woodfall Films in the 1950s, the group stopped filming halfway through because they were 'knackered, cold, wet and poor' (Swain 1985: 54) and took the opportunity to set up a company, Yeardream Film Ltd, to deal with contracts, represent the interests of the crew and distribute profits after the film's release. Meantime, both FilmFour and Palace Pictures were interested in the film, and eventually a deal for distribution and exhibition was made.

Another aspect of their approach to film-making which enables us to draw parallels between previous social realist practice and politics in Britain is the way the film-makers saw *Letter to Brezhnev* as the people's film. Swain claims that 'the people of Kirkby saw it as their

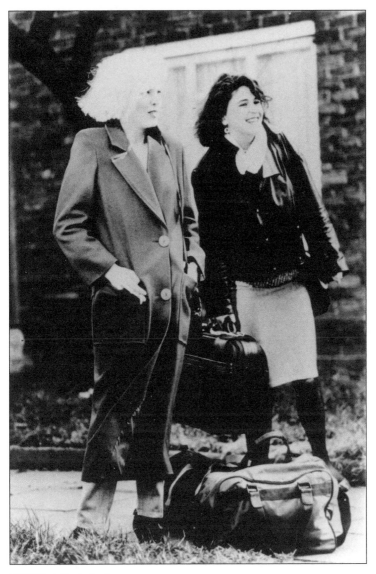

FIGURE 6 *Letter to Brezhnev*

film. After all, Frank, a local boy, had written it, and it didn't show the usual TV picture of environmental misery, but instead the good and happy spirit of a community who deserve better' (1985: 54). So, despite the film-makers' love affair with the glamour of Hollywood, we can hear in Swain's words echoes of Edgar Anstey and Arthur Elton's claims that *Housing Problems* (1936) was the slum-dweller's film, and of Humphrey Jennings' concern that the people of Lidice have their say in *The Silent Village* (1943).

The film was shot on location in Kirkby and Liverpool with the support of the local community and local businesses, who responded to an ingenious pre-shooting publicity campaign to gain the interest and support of the people. Consequently many of the businesses gave their services for free or at a reduced rate (see Swain 1985). Even trade unions who were concerned about the crews agreement to work for deferred wages relented and gave the film-makers their support. Swain concludes they did not pursue the issue because 'anything bringing employment to the region needed to be supported – particularly when the people were doing it themselves' (1985: 54). Clearly, then, part of the film-makers' strategy here was to encourage local support of the film and to foster a sense of ownership of it at a time when Liverpool and its people were under attack politically, economically and in the media.

A final strategy in practice terms which enables us to draw parallels with British social realist practice in previous eras is the use of unknown actors. Of all the characters the only actor to have any kind of name was Peter Firth who had acted on stage and had starred in the film version of Peter Schaffer's disturbing play, *Equus* (1977). Alfred Molina, although a well-known and respected actor nowadays, was a little-known face to film audiences, and Margi Clarke and Alexandra Pigg were screen newcomers. Also, *Letter to Breshnev* used local papers and radio to get extras for the scenes in the State Ballroom. And as Swain observed, 'hundreds of young people turned up eager to be extras: it may have been a miserable Monday morning, but the place had the atmosphere of the best Friday evening out on the tiles' (1985: 54).

In terms of content the film's themes, the issues it explores, and its representations both continue and subvert many of the features of previous British social realist texts. The issues of unemployment and soul-destroying work are obviously present but, as with the New Wave

films of the 1950s and 1960s the central protagonists are more interested in their leisure activities and put all their energies into having a good time. Thus the trend identified by Hill of leisure displacing work in British social realist films is evident. Leisure – drinking, dancing, sex, and gossip – are the ways the two young women cope with poor employment prospects. In terms of themes, however, *Letter to Brezhnev* concerns itself with dreams, fantasy and escape from social, economic and familial realities. It is, in essence, about never giving up, but this message is addressed to the individual and therefore is not an appeal to the embattled working class people of Liverpool or Britain. *Letter to Brezhnev* is a political film, but on a personal level. *Monthly Film Bulletin* recognised this:

> Of course, this is a political film: it's about youth unemployment, inner-city decline, and almost every other evil of our times. But it is also about two girls who are a great deal brighter and wittier than most of those around them and whose calculated priority is pleasure. (Forbes 1985: 310)

This brings us to the issue of representation in *Letter to Brezhnev*. In many ways Elaine and Teresa are the female Arthur Seatons of their day: all energies and talents displaced onto the pursuit of pleasure, involving casual sex and drinking, and getting dressed up for a weekend's reprise from the factory. Teresa is probably the closest approximation to the Arthur Seaton archetype: she is vain, reckless and irresponsible, she uses men as Arthur uses women, and, left behind in Kirkby with her factory job and only the pleasures of the weekend to look forward to, the implication is that she, like Arthur, will eventually settle down to an 'ordinary' existence. The difference between them – aside of the obvious gender difference – is that Teresa had a dream and failed to follow it, whereas Arthur had no dreams or goals to pursue.

In terms of representation the film successfully redresses the gender imbalances of the British New Wave by putting female protagonists at the heart of the narrative. This is in line with the social realist impulse towards social extension. Much of the film relies on role reversals – the women are sexual predators, they are the bread-winners, and many of the men in the film are portrayed as economically dependent on women. Even Teresa and Elaine pay for the hotel they share with Peter and Sergei, much to Teresa's disgust.

However, the text's progressive potential is undermined by the fact that for all their public confidence and sexual assertiveness, both Teresa and Elaine are still basing their happiness on finding love and attracting men. Of course, it could be argued that Teresa, in particular, is cynically using her femininity to get what she wants and that the joke is on men for falling for it. But she is still tied to the very patriarchal system she manipulates and this will ensure she remains trapped. Conversely, while Elaine's initial impulse was to go to the USSR to be with the man she loves, this is less of a reason for her going in the end. Love is not the point, but rather the fulfilment of a dream to escape her drab existence in England – that may or may not include 'true love' – is the point. In short, by the end of the film, with or without love, she will follow her dream.

In contrast to these strong female protagonists the majority of the men in the film are portrayed variously as weak, foolish, impotent, dishonest and obsessed with sex. Men cannot be trusted and are targets ripe for exploitation. Only the black cab driver is seen in anything like a positive light and Teresa turns down the chance to escape paying the cab fare by saying 'he's one of us'.

In terms of form and style it is interesting to note that the film's hybrid nature – part love story and part social realism – creates a tension. This, in turn, forms the basis for two further tensions in the film: between poetic and social realism, and dreams and reality. The film's narrative form works in a fairly conventional cause/effect way and so is less episodic than the majority of British social realist texts of previous eras. The film centres almost exclusively on Elaine and it is her actions and desires which provide narrative motivation. However, this is undercut by the ambiguous ending. Typical of British social realist texts, *Letter to Brezhnev* in its resolution leaves more questions unanswered than resolved. She has escaped, but to what?

Stylistically the film shares a number of conventions with previous social realist films most notably the way it displays a tension between space and place and Higson's (1996) arguments relating to space, place and spectacle of kitchen sink film of the 1950s and 1960s can also be applied to 1980s' social realist texts like *Letter to Brezhnev*. This is facilitated by the use of an unusual number of aerial shots over the city. These shots work on one level to show the location of the action, but also signify Liverpool as a real location. The aerial shots also work to distance the

spectator from the protagonists and their experiences, so what looks drab and depressing on ground level 'where it is lived', looks beautiful from the lofty position of film-maker and the spectator. It is interesting that these shots are so prevalent in the film since, as we have seen, they felt they were part of the community they filmed.

The tension between poetry and realism can be seen in *Letter to Brezhnev* and here this tension stems from its dual-genre approach. Poetic touches can be seen in the extensive use of aerial shots, the sequences of Elaine walking along the waterfront at twilight mirroring the sun setting on her dream, and the dancing sequence in the State Ballroom where everything slows down and the soundtrack changes from diegetic to non-diegetic music. These poetic sequences work against the surface realism of the factory gates, nightclub toilets and the chipshop. It is the moral realism – the universal human values of the film – that allow the two to co-exist. For in *Letter to Brezhnev*, dreams can become reality if you believe them and do not give in.

This can be seen in the other tension coming from the hybrid nature of this film: between dreams and reality. In the film, not only can dreams become reality, sometimes dreams even seem like reality. This is illustrated in the scene where Elaine and Peter have sex but is revealed to be a dream. The scene in the State Ballroom sees the reverse occurring. Reality becomes dream-like as she spies Peter, and dances and flirts with him. This relationship between dreams and reality can be seen as an articulation of the film-makers interests in the magic of Hollywood and the way they attempt to transplant it in a text bearing all the marks of social realism.

In spite of its differences from Loachian social or critical realism and its differences to the New Wave social realist texts in terms of the representation of gender, *Letter to Breshnev* shares many formal and stylistic features with its predecessors. It also shares a commitment to community which many of the Griersonian film unit's film-makers believed in. Also evident is a respect for a perceived 'never-say-die' spirit and again, this concern connects Bernard and his team to the social realist tradition in British cinema. The makers of *Letter to Brezhnev* also share certain aspects of film practice, working with small budgets, shooting on location and with little-known actors. Certainly their struggles for money and distribution and exhibition deals would also be something that Jennings, Grierson, Anderson, Richardson, Reisz and Loach could

identify with. But there are significant differences which mark this film out as an 1980s British social realist text, not least of all its reaction to Thatcherism and its playful reversal of gender roles along with its generic and stylistic hybridity. This hybridity and playfulness are features which have continued in contemporary British social realism and this is the focus of the following chapter.

6 1990S AND BEYOND: CONTEMPORARY SOCIAL REALISM

The changes begun in the 1980s have continued to shape the British film industry. These changes have also had an impact on the production, distribution, and exhibition of social realism in Britain, as this chapter will illustrate. Whilst certain well-established conventions have been maintained, some have been transformed and transmuted. In addition, the hybridity in form and style, and the shifts in terms of themes, issues and representations, pose new questions for British social realism – not least of all the question of what kind of future do British social realist texts have in a global market. The latter issue will be taken up in the conclusion, while this chapter will set the scene.

British film and television in the 1990s

As we have seen in the previous chapter, a new relationship developed between television and film in the 1980s. However, in the 1990s this 'delicate ecology' was disturbed by changes wrought by the Broadcasting Act 1990, particularly its impact on Channel 4. Under the Act, Channel 4 was made responsible for raising its own advertising revenue. Thus Channel 4 was forced to become more competitive in terms of competing for advertising with the other commercial channels, and because of this it was under pressure to attract more viewers. This meant that gradually over the decade Channel 4 reduced its investment in feature films and targeted the funds it did have available more carefully, and its support of independent film and video workshops also declined as a

consequence. Yet Channel 4's film investment was not the only casualty of the Broadcasting Act.[1] The ITV companies were also affected: the three companies with a major stake in film production in the 1970s and 1980s – Thames, Granada, and Central – all reined in their film-making activities to varying degrees. The Broadcasting Act brought in a new system for awarding licences to broadcast as part of the ITV network. The franchises were all open to competitive tender and Thames lost out to Carlton Communications. Because of the franchise system funds available for programme-making were reduced and this had a knock-on effect on the investment the television companies were prepared to make.

At the same time the development of satellite and cable television also put the terrestrial companies under pressure, although one satellite broadcaster, BSB, committed money to the production of a limited number of British feature films. The rise of video also increased the pressure on television whilst at the same time creating an important revenue source for feature films. So, on the one hand, film-making in Britain, having been tied more closely to television in the 1980s, suffered as a result of the decreased interest of television companies in investing in feature film-making. And yet there is also a sense that the popularity of video gave a second life – or even a first – to British feature films that perhaps received a limited release or those that were denied a theatrical release.

At the start of the 1990s significantly fewer films were being made as a consequence of the disruption of the 'delicate ecology' established between film and television in the preceding decade. However, by 1996, as Robert Murphy (2000) observes, more feature films were being made but proportionally fewer were achieving theatrical distribution. This might be accounted for by the measures introduced by the Conservative government under John Major to help stimulate production. First, the British Film Commission was given the brief to market British films overseas. Second, a European co-production fund was established. Third, the UK subscribed to the Council of Europe's production and distribution support fund, Eurimages. Fourth, tax relief was offered to film production companies from 1992. And finally, lottery funding was made available to film-makers (see Nichols in Block 2001).

The challenges that met British film-makers in the 1990s did not just include changes in the industry and in the relationship between film and television. Geoff Brown (2000) argues that there were broader changes in film culture in Britain. More people were now watching films on television

that in the cinema and film became a popular area of interest. New film magazines emerged – *Total Film*, *Empire*, for example – and some critics believed popular interest was 'dumbing down' critical writing on film. Loach observes: 'Certainly in Britain there's a lack of a serious critical tradition beyond *Sight and Sound*. The vast majority of film reviews are strictly consumer-oriented' (Loach in Fuller 1998: 83).

With increased competition in the national broadsheets, new and lengthier sections on film appeared in the Saturday and Sunday supplements. Brown also points out that more universities than ever before were offering media or film degrees: from 166 courses in 1990 to over 280 in 1998. In spite of this explosion of interest in film in the 1990s, British cinema has remained in Hollywood's shadow. Brown notes how the market share in Britain for British films is the same as its share of the audience in Spain. Stuart Hanson contends that the period between 1996 and 1998, which saw an increase in the numbers of multiplexes, also saw dramatic increases in the numbers visiting cinemas. However, it is not working class audiences swelling the numbers, but rather an increase in the numbers of professionals/managers (ABC1s). The numbers of working class (C2DE's) spectators has decreased and this is widely attributed to the rise of satellite, cable and digital television (see Hanson 2000).

The increases in screens and audiences in cinemas should mean that there is more choice for cinemagoers, but in reality this is not the case. British films struggle to compete with Hollywood blockbusters. It is also important to note that when it has had successes, the British film industry has a poor track record in benefiting financially from any such success. For example, *The Full Monty* received its entire backing from Twentieth Century Fox, so whilst it was regarded as a success for the British film industry 'the films profits went to America' (Brown 2000: 33).

British social realism: impact of changes in film industry and culture

British cinema on the whole can sometimes be regarded as either not cinematic enough or not 'big enough' for cinema. As Julian Petley says:

> It often seems as if British films are doomed to be disparaged by the critics whatever they do: in spite of the Griersonian legacy, naturalism is simply dismissed as too televisual ... while those who

go in the opposite direction … are almost universally criticised for being too flashy. (1992: 93)

Thus there remains a palpable sense in some circles that British cinema is still associated with a Griersonian legacy, but that anything that is not Griersonian is inevitably 'flashy'. It articulates the dilemma British cinema has faced since the 1920s – to compete with Hollywood or to develop something of its own. As we have seen, the position of social realism in British cinema has been portrayed as characteristically anti-Hollywood and this was, by contrast (and as a consequence), deemed to be enough to be 'typically British'. While British cinema in the 1990s has been trying to find its identity in the global market context, film-makers are variously adapting, adopting or paying homage to American cinema rather than setting themselves in total opposition to it.

Given the kinds of projects receiving financial support in Britain it is clear that certain types of film are seen as more viable than others. British social realist cinema does not use stars in the way Hollywood films do. They do not have spectacular special effects, do not attract merchandising deals and cross media tie-ins in the same ways as Hollywood blockbusters. Trowell notes that 'films that do not offer a big name have to fight for screens against unfair odds' (Trowell in Petley 1992: 84).

But whilst they may not have stars, a trend begun in the 1980s seems to have become more pronounced as British films are increasingly marketed by reference to specific directors. Directors working in the social realist mode, like Loach, Leigh, and more recently Lynne Ramsey and Paul Pawlikowski, are being used to sell films to a niche market we might loosely term 'art house'. The film-maker-as-author angle in marketing British social realist films took an interesting turn with, first, Gary Oldman's semi-autobiographical *Nil By Mouth* (see case study below), and later Tim Roth's debut, *The War Zone* (1999). The star-author in British social realism is a new development which in many ways confirms Higson's assertion that realist tendencies in British film have been characterised by a move from public to private, and personal. This concentration on the director as author with his or her own unique signature style, themes and concerns, is another factor in the marketing of British social realist texts to an 'art house' audience both here and internationally (although it should be noted that those newcomers being marketed in this way have yet to establish a body of films in which to articulate or perfect specific concerns

or styles). As they are increasingly marketed in this way, they simply do not get the opportunity to play in multiplexes. While directors such as Ken Loach and Mike Leigh can still raise finance and even profits, they cannot compete with Hollywood blockbusters nor successful star-centred, highly-promoted British films.

Opportunities, then, do exist for social realist films in the current climate, but from the 1990s the trend has been for such texts to be marketed as products of authors, to niche-marketed art house audiences and to have their short exhibition lives extended via sale through to video and television. Social realist texts win praise from critics and prizes at international film festivals but relatively few enjoy anything like as wide a theatrical distribution as the most average Hollywood product. Ken Loach and Lynne Ramsey are two notable examples. Indeed, Loach's most recent film, *The Navigators*, whilst being theatrically released across Europe, received its first airing on Channel 4 television.

Since market forces dictate so much of what we can see on television and in the cinema, it follows that once a film has been successful another like it is attempted in order to capitalise on, if not to replicate, its success. So, after *Brassed Off*, and more importantly, *The Full Monty*, other 'working class' comedies soon followed (*Up and Under* (1997), *TwentyFourSeven* (1998)). After *Four Weddings and a Funeral* (1994), *Sliding Doors* (1998) and *Notting Hill* (1999) seemed inevitable.

Social realist texts, of course, are alive, if not necessarily well, and living in television although it is notable that once again – as in cinema – Andrew Higson's assertion about the public and the private can be confirmed. Dramas focus more tightly on family relationships and partnerships. Poverty, unemployment and social exclusion are not the driving forces of their narratives, but are merely signalled as contributory factors to family strife, so that it is the working class family that has failed, not the state or capitalist society. The drive for ratings on television, particularly in the light of increased channels in the digital age, means that popular programmes spawn a rash of look-a-likes and spin-offs. This crams the schedules with what the audience is proven to like, which in turn ultimately pleases advertisers. 2001 saw a drop in money spent on advertising and this has caused difficulties for the terrestrial channels in Britain, particularly. The need to attract advertisers means that channels are under pressure to abandon public service principles in favour of providing more populist fare. As a key mode of expression in British film and television, social

realism is bound to feel the effects of this trend. Yet there does seem to be something of a renewed interest in social realism as this book is completed: recently both the BBC and Channel 4 have found room in their schedules for major social realist dramas and feature films, including *Tina Takes a Break* (Channel 4, 2001), *The Navigators* (Channel 4, 2001), *Care* (BBC, 2000) and *When I Was Twelve* (BBC, 2001).

In 1980s social realist texts the consequences of Thatcherite social and economic policies were foregrounded and to a degree this has continued thematically into the 1990s. Below we will explore three key thematic concerns in contemporary social realism: the crisis in masculinity, the de-politicisation of the working class through a shift in emphasis from production to consumption, and the prevalence of a therapeutic discourse in social realist texts.

Masculinity in crisis?

It has been noted by some critics that issues relating to unemployment, poverty, drug and alcohol abuse are constituents not merely of the decline of the traditional working class, but symptomatic of a crisis in masculinity (see Hill 2000a; Monk 2000b; Luckett 2000).

For John Hill, British social realist texts of the 1990s articulate a certain 'weakening of the ideologies of masculinity', and he identifies two specific approaches evident in contemporary texts – failure and utopianism. The former, taken by Loach and Oldman for example, shows men caught in circumstances they cannot or will not change (2000a: 178). So in Loach's *My Name Is Joe*, there is only defeat for the film's central protagonist. And in Oldman's *Nil By Mouth*, Ray's alcoholism, drug abuse and violence are not properly addressed, which renders the whole family vulnerable to the turbulent effects of the cycle of abuse when it inevitably begins again. The latter approach identified by Hill – utopianism – can be found in films like *Brassed Off*, *TwentyFourSeven* and *The Full Monty*, whereby through collective action and mutual support, men can work together to earn a living and reclaim their dignity after the emasculating effects of unemployment. These social realist comedies provide a fantasy resolution that rescues men from the brink of crisis. So, for example, whilst *The Full Monty* takes as its historical point of reference the collapse of heavy industries during the Thatcher administrations, it actively works to 'heal the wounds' through a Blairite 'things-can-only-get-better' optimism.

Monk also notes that British films of the 1990s in general 'seemed preoccupied with men and masculinity in crisis' (Monk 2000b: 157), but she argues that the resulting films were fuelled by a post-feminist backlash as women gained ground on men socially and economically. However, Monk concedes that this 'male panic' and anxiety was not clear-cut. Rather images, messages and meanings are deliberately blurred to ensure films gained a wide appeal and to address the political concerns of both sexes. She points out that in films like *The Full Monty* and *Brassed Off* the concern expressed for the working class is rather concern over the loss of a working class male community and identity. Indeed, she contends that both films display a barely concealed hostility towards women and the de-industrialised, consumer-led, feminised world. The misogynist tendencies of social realist texts of the 1950s and 1960s seem to be reborn in contemporary British cinema – if indeed they ever really went away.

Place and space are still divided in terms of gender in 1990s social realist films. However, as we saw in the previous chapter, a blurring was taking place, between 'traditionally male' and 'traditionally female' places. It could be argued that some 1990s social realist films attempt to re-draw certain boundaries in terms of gender. For example, in *The Full Monty*, there is a symbolic battle for one place in particular – the working men's club. At the start of the film, in a neat reversal, the working men's club has been taken over by women who go there to watch male strippers. By the film's climax the men have taken the club back and are centre stage once more. They are in demand and by working have reclaimed their male dignity and identity, without, Hill notes, having to suffer the indignity of 'going the full monty', as a female stripper might have been expected to do (2000a: 184). However, this is an ambiguous resolution. In spite of the 'feel-good' ending of the film, in return for their re-masculinisation they have commodified themselves. It could also be argued that there is a similar commodification of working class culture and identity in the film itself that has an eye on the international marketplace. *The Full Monty* imagines a community in a place which has successfully recovered from the wounds inflicted upon it by one woman in particular, and women in general.

Production to consumption: the de-politicisation of the working class

In the light of de-industrialisation, deregulation and privatisation, social realist texts portraying working class lives increasingly do so by defining

them in terms not of what they produce but rather what they consume. This in turn figures the working class in terms of the politics of the personal. This thematic preoccupation was noted by Higson in the kitchen sink films of the 1960s which corresponds to concerns amongst the New Left (taking their position from Hoggart and Williams) that consumerism was destroying the traditional working class culture. This thematic concern continues in 1990s social realist texts. The focus on families and individual struggles became even sharper in the 1990s, continuing to fulfil Higson's argument that the history of realism in British cinema is characterised by a movement away from the public into the private. Hill sees this concentration on the discontented male protagonist not only as a continuity in theme but one that is intensified in the 1980s and 1990s (2000b: 259). Furthermore he, regards these particular traits of British social realism as weakening the political and social messages of the texts.

Julia Hallam argues a similar point: that these films construct their images of the working class through 'their relation to consumption rather than production, purchasing power rather than labour power' (2000: 261). Moreover, Hallam traces a certain continuity between the 1990s films and the earlier kitchen sink cycle.

From the public to the personal: family life and the therapeutic discourse

The move from production to consumption has taken an interesting turn in films focusing on what Monk calls 'the underclass' (2000a: 274). Consumption now, it could be argued, can be extended to include not only where working class characters go in their leisure time, and the decreased significance of work (as production) but also to what they literally consume and how what they consume also consumes them. The sharper focus on family life has, in the 1990s, allowed new issues to become part of the social realist vocabulary. As we have noted throughout, social realist texts are tied to their contemporaneous situations. Alcoholism and drug abuse are commonplace issues in social realist films and television dramas to such an extent that in spite of public education campaigns and school initiatives one might imagine that such substance abuse was de rigeur for a certain type of working class family. This brings to mind the careful delineation between the rough and respectable working class of previous social realist moments. Without a strong tethering of thematic concern to the narrative action and the surface realism to explain the reasons

for drug and alcohol abuse, the presence of these social problems is at best divested of any deeper meaning and the issues become instead part of the iconographic shorthand signifying the 'bad' working class or 'underclass'. In addition it could be argued that by focusing too tightly on an individual's drug and/or alcohol abuse, these social problems become personal problems. The rise of counselling or therapeutic discourse and its growing prevalence in media discourses in general (from *Oprah* to *EastEnders*) reinforces this since only the individual can decide to change for themselves. Audiences are sensitised to this discourse. For example, in his feature on *Nil By Mouth* for *Sight and Sound*, Nick James observes: 'It's a brand of realism that in a way acknowledges that British audiences are now "more in touch with their emotions"' (1997: 8). If Colin MacCabe's metalanguage exists in contemporary social realist texts, then this is its new and preferred moral position. Coupled with the tighter focus on family life and individuals signals a major shift from the politics of the social and the public, to the politics of the personal and the private.

Given these thematic continuities and shifts, it follows that there are certain continuities and certain changes in the ways characters are represented. In spite of significant shifts in the representation of the male working class, there has been comparatively little preoccupation with race and sexuality. At the same time a new representational emphasis can be discerned in the portrayal of, and centring on, the children of the working class.

Class and gender

As we have seen, one of the major thematic shifts in social realism has been, rather, a large step back to the first twenty years of the post-war era – back to the days when at least in British cinema, working class men had a distinct identity and a distinct sense of community, even if they were portrayed as collapsing or under threat. But the working class has changed. De-industrialisation meant that working class men could (at least in market research terms) be better identified by what they bought or watched or where they went on holiday, than by the type of job they did. So we must extend Monk's claim that British cinema – and for our purposes British social realist cinema – articulates a concern for the situation of heterosexual, white working class males and there are very few exceptions to this (*Secrets and Lies*; *Bhaji on the Beach; BabyMother* (1998)). Hill

points out that the socially conscious Ken Loach, for example, does not extend the working class to include representations of minority cultures, whereas the communities in the more mainstream, populist social realist comedies like *The Full Monty* and *Brassed Off* include black characters and gay characters (2000a: 186).

Like previous cycles or moments of social realism in Britain, the films of the 1990s tend to focus on male protagonists. They may be depicted as perhaps more flawed, more dangerous, or more deluded than Arthur Seaton and Jimmy Porter, but as Monk suggests, they are received to varying degrees, sympathetically and this is largely because of the perceived 'losses' the narratives signal: losses of work, dignity, self-respect, familial and personal relationships, economic, political, social and sexual power and 'potency'. Monk goes further and suggests that these losses are more strongly articulated as 'problems of gender, rather than economic relations' (2000a: 160). Few social realist texts have centred on working class female protagonists. Notable exceptions include *Stella Does Tricks* (1997), *The Girl With Brains in Her Feet*, *Secrets and Lies*, *Ladybird, Ladybird*, *Bhaji on the Beach*, and *BabyMother*.

Women are once again portrayed as 'agents of consumption', whether it is the co-dependent consumption of Kathy Burke's Val in *Nil By Mouth*, or the nouveau riche aspirations of Linda (Deidre Costello) in *The Full Monty*.

Children as protagonists in social realist texts

With a sharper focus on family life and the struggles of individuals caught in cycles of poverty and abuse in the 1990s has come a new representational emphasis that is not without precedent in British social realist cinema. Many films and television dramas seem to have shifted their attention to the children of the working class. This should be seen in the context of the times. Over the last twenty years, children and their problems and issues have become more prominent in society for a number of reasons: the aforementioned prevalence of a counselling discourse adapted and adopted by a range of texts from teen magazines to prime time soaps and talk shows, the improved campaigning techniques of organisations like the National Society for the Prevention of Cruelty to Children and the establishment of cross-media telathons and events like the BBC's Children in Need Appeal, and Comic Relief's Red Nose Day, the

creation of Child-Line, and the provisions of the Children Act 1989. The success of these organisations and events have also to be seen within the context of sporadic moral panics about 'the kids of today'.[2] One such peak of concern emerged after the death of James Bulger and the subsequent debate about who was to blame – parents, teachers, the media or the devil? In more recent times, the murders of Stephen Lawrence, Damilola Taylor and Victoria Climbie also raise concerns for the safety and well-being of children.

In addition, the child abuse cases in Cleveland and in Clwyd, and the paedophile panics which came to a head in the summer of 2000, in the aftermath of the murder of Sarah Payne, have also served to put children on the social agenda. In line with the extentionist urge of realism, contemporary British social realist texts have increasingly not only incorporated the experiences of working class children into their narratives, but have also made them the central protagonists. This development is certainly not without precedent: J. Lee Thompson did this in *The Yellow Balloon* (1952) and *Tiger Bay* (1959), as did Bryan Forbes to a lesser extent in *Whistle Down the Wind* (1961). Ken Loach's *Kes* perhaps offers the best known example in this context. But there has been in recent years, in our child-sensitive society, a marked increase in the representations of children in working class families. Examples of this can be seen in *Nil By Mouth, The War Zone*, the BBC's *Care* (2000) and *When I Was Twelve*, and Channel 4's *Tina Takes a Break* (2001). This poses new questions for audiences, critics and theorists. How do we identify with a twelve-year-old girl or a six-year-old boy? Are we more distanced because we cannot directly align or identify with their world view, or are we being addressed as parents or potential parents? Are working class parents being addressed, or are these films merely reminding middle class audiences of how lucky their own children are? What position are we being invited to take – observer or social worker?

Style and form

The concentration on authors and their distinctive style has increasingly come to define social realist texts in the contemporary period. This in turn makes the films more viable as 'art house' productions, enabling them to find an audience – albeit a restricted one, in terms of theatrical distribution, as discussed in the first section of this chapter. Therefore, to speak of style

in contemporary British social realism is to speak rather of a plurality of stylistic approaches ranging from the naturalistic, observational style of Ken Loach, to the poetic, even hypnotic style of relative newcomers like Ramsay and Pawlikowski.

In terms of form at its most basic level, however, there are few changes. Social realism is still considered to be a 'televisual' mode of expression. However, the hybridity of style is matched at the level of narrative form in some instances. For example, *Nil By Mouth* has a cyclical narrative and a loose episodic structure, as is characteristic of social realist texts, but it also contains extended montage sequences cut to the soundtrack in such a way as to be suggestive of a music video. Similarly, the social realist comedy *The Full Monty* makes use of montage sequences cut to soundtrack and also spawned a re-release of Hot Chocolate's single 'You Sexy Thing'. It could be argued that the place and prominence of the soundtrack in British social realist texts (indeed many British films and television programmes) is a consequence of a synergistic market which requires that films raise revenue through soundtrack albums.

Despite a range of styles, all social realist texts identify themselves by conforming, to varying degrees, to the iconography of British social realism – stark urban landscapes, run-down seaside towns, vandalised parks and council estates strewn with burned out or abandoned cars. The use of real locations and the attendant tension identified by Higson (1996) between space and place are evident in contemporary social realist texts. For example, in Dominic Savage's *When I Was Twelve*, the children run away to Hastings – a real (and highly historic) 'place'. For them, Hastings represents freedom from family strife. The seaside, for children – and for inner-city children especially – is always magical, and the seaside is a familiar location in social realist texts: Margate is used as a site for the struggle between traditional working class culture and the vulgarity of the affluent working class in Anderson's Free Cinema documentary *O! Dreamland*. Colin escapes to the seaside with his friend and girlfriend after stealing money in *The Loneliness of the Long Distance Runner*. And Pawlikowski revisits Anderson's Margate in *Last Resort*. *When I Was Twelve* uses the names and locations of real streets and clubs in the narrative to authenticate its fiction. Certain well-worn conventions of shot can be found, like 'That Shot Of Our Town From That Hill', and other sweeping wide-angled shots of cities and towns.

The emphasis (and marketing) on individual authors has led to a range of formal and stylistic practices being adopted by film-makers in contemporary social realism. Yet it could be argued that as film-makers strive to deliver a more individuated product to a fickle global market, the temptation to favour style over content could serve to further disconnect the public from the personal and the social from the private.

Case study: Nil By Mouth

Gary Oldman's film is a semi-autobiographical tale of a working class family doomed to repeat the cycles of abuse and violence from generation to generation in perpetuity.

All the features and conventions of British social realism can be found in *Nil By Mouth*: 'loose' episodic narrative structure with a cyclical resolution and ambiguity defying the closure demanded by mainstream cinema; the use of location shooting; the use of non-professional actors and well-respected 'small picture' actors like Ray Winstone and Kathy Burke (surely the Albert Finney and Carol White of our times), in an ensemble cast; the use of naturalistic light, sound and dialogue; high angled shots of depressed urban environments, along with the 'gritty' sights and sounds of a certain way of London life – like laundrettes, pubs, strip clubs and Underground trains. Yet this film is noticeably different and has features which mark it out as a contemporary British social realist film. In line with the point that increasingly social realist texts are being marketed in terms of their directors, *Nil By Mouth* is doubly important since, of course, this was an acknowledged semi-autobiographical film made by a well-respected British film star. Therefore it had added appeal and could be marketed and exhibited to a wider audience. The film's production connection to Luc Besson also added extra cachet for its run in continental Europe. The fact that this film is acknowledged by Oldman to be 'about' his own relationship with his alcoholic father also bears out the point that, increasingly, social realist texts are moving from a concern with the public to a preoccupation with private worlds.[3] In the case of *Nil By Mouth* this is again doubly important because not only does it focus tightly in on the screen family and its problems, but by its nod to the director's own background, could almost be considered therapy for Oldman. In an online interview Oldman responds to a question about why he made *Nil By Mouth*: 'It was in me. It was almost like the solution I'd been looking for to a problem.'

The criticism of this focus on the personal and the private argues that the concentration on the family's problems undermines any sense of the social and economic reasons that might lie behind alcoholism and domestic violence. Oldman's film is certainly new and refreshing in one respect: that a social realist film has even been attempted in recent years by someone who has actually come from not only the background, but the actual locations used in the film. However, Oldman's status as a 'working class film-maker' is somewhat undermined by his celebrity and wealth. He is the 1990s equivalent of the scholarship boy, looking back but glad to have escaped.

It is not enough in an era of widening access to education and vocational training to merely limit ourselves to Lindsay Anderson's desire to represent the working classes in British film culture. While Oldman is certainly an exceptional (and problematic) case, we should be encouraging more working class film-makers to show us their social realities. The directors of the British New Wave could only respond to a moment they helped to construct but did not live. By contrast, in *Nil By Mouth* Oldman is both author of and part of the text, using the camera to 'look again' from a safe distance at his own remembered past.

Thematically, the film is not concerned with social, political and economic inequalities but is rather concerned with the disintegration of working class family life and this concern is solely represented by the concentration on one family and its extended network of relations and friends. Any linking of the family's problems with wider comment about the nature of society is communicated by situating the action in 'real' locations.

There is also a concern for the state of working class masculinity. Ray (Ray Winstone) is represented as a charismatic but essentially weak man, a needy child in an adult's body, half the child he was, half the man he does not want to become – his father. The cyclical nature of the narrative indicates that this will continue (in this respect perhaps Oldman's own understanding of personal encounters with therapeutic discourse informs the narrative structure), since unless the individual recognises they have a problem and until the family stop enabling the alcoholic to continue, cycles of abuse will continue. For Ray and for Oldman, alcoholism is a family disease and not a societal one. This is also the logic of a certain therapeutic discourse grounded in cognitive psychotherapy.

Whilst the film certainly critiques a working class masculinity removed from production and defined by consumption (leisure activities, drugs,

FIGURE 7 *Nil By Mouth*

and the pursuit of women), it is, Monk argues, more focused on the male community and as such displays a certain sympathy for its members. The narrative action revolves around Ray and his friends: 'Despite its seemingly critical stance on Ray and his mates, the film spends far more time with them than with Val – suggesting an enduring fascination, more widely evident in 1990s British films, the with unreconstructed world of men' (2000b: 165).

But its representation is ambiguous: for example, the innovative use of the camera creates a tension in the spectator between intimate involvement and critical distance. This strategy has a different intention and motivation to that of other directors precisely because of Oldman's personal investment in the film. The camera pans alongside characters, moving around static objects slowly as it follows Ray and his friends. Monk suggests that the movement of the camera prevents identification with the characters. Oldman wanted to achieve a drama-documentary look to 'achieve a very natural feeling'.[4] But the camera movement is also suggestive of someone who is on the 'outside of the inside', as Oldman undoubtedly is because he has left that world behind.

The complete absence of any nostalgic romanticisation of the landscape is avoided. As we have seen, Higson (1996) notes, in relation to the kitchen sink films of the late 1950s and early 1960s, that the city can only be beautiful from a position outside it. In the case of *Nil By Mouth* the city is not beautiful precisely because this film is not so much a projection of modern Britain but a re-construction of Oldman's experiences of it, of someone who lived it and escaped.

In the 1980s social realist texts we saw how a certain blurring of the spaces male and female characters occupied in texts had occurred. In the 1990s, this blurring continues but it seems there is some resistance to this in *Nil By Mouth*. Outside of the home, men clearly dominate. For example, on their night out 'up' the West End Ray and his friends tour round a 'masculine London' of bars and strip clubs, leaving Val at home with the television and the children. Another example is the gendered world of the traditional working class pub featured at the film's opening, where females are seated at tables whilst the males crowd round the bar. However, in contrast, in one scene Ray is to be found in a pub drinking alone, and the camera steps round him at a distance which suggests that he cannot count on his male community and that his machismo is wasted in an empty pub.

There are a number of features which mark this film out as formally and stylistically innovative – from the fuzzy, yellowy light used in most scenes, to the Cassavetes-inspired long takes and the use of sequences cut to music reminiscent of pop videos. This latter feature is particularly noticeable in the long sequence beginning with Billy scoring his heroin from his dealer while his mum waits for him in her van. The sequence works to disperse our concerns more widely across the characters, undermining over-identification with Ray and his mates. This, it implies, is a family where all, from the most 'powerful' to the least 'powerful' are suffering, detached from each other and miserable. This is a family of slaves – Billy to drugs, Ray to booze, Val to Ray, and her mum to the family.

The camera is always moving, or 'fidgety' in the words of Geoffrey McNab, reviewing the film for *Sight and Sound* (1997: 55). Monk has described *Nil By Mouth* as 'one of the most cinematically extraordinary British films of the decade' (2000a: 164) and she attributes this largely to Oldman's personal commitment to the film. She notes how the headline under which the film is reviewed in *Sight and Sound* – 'Being There' – summarises the audiences relationship to the film. We are only

permitted to 'be there' to such a degree because Oldman already has. In this article, Nick James articulates the view that *Nil By Mouth* represents a shift in British realist cinema, which he identifies as cinematic as opposed to televisual:

> Like many films financed by television over the last decade or so, Oldman's film has a preponderance of close-ups of people in confined spaces, yet they are lit and lensed in such a way that it never feels less than a cinema experience. (1997: 6)

Thus, like the film-makers of *Letter to Breshnev*, the influence of American cinema is evident. Furthermore, James also identifies the prevalence and effect of the therapeutic discourse, discussed above to explain the differences between Leigh and Loach's social realism and that constructed by Oldman: 'Brechtian distanciation is here supplanted by an intimate relationship to the film subject, one born from psychotherapeutic models' (1997: 8). For James, this discourse is perhaps the biggest change in British social realism that *Nil By Mouth* signals.

Yet it is not all change on the social realist front in Britain. That British social realism stands in stark contrast to the mainstream cinematic products in circulation is still considered a defining feature, but it is now a feature which does not have to compete with American cinema. As James notes: '*Nil By Mouth* supplies a fresh antidote to the current Hollywood output of event movies, without setting itself in opposition to all American cinema' (1997: 8).

As we have seen throughout the preceding chapters in this book, British cinema has a rich tradition in social realist film-making. It has been an influential mode of expression throughout British film and television history, always adapting, developing and changing but nevertheless maintaining certain conventions in film practice, form, style and content. The conclusion which follows seeks to address the meaning of British social realism at the start of the twenty-first century, whilst raising questions about its future direction.

CONCLUSION

In this final section, we will first sum up the continuities in British social realist texts before examining some of the main discontinuities, then proceeding to raise some key issues and questions for contemporary British social realism. Finally, we will briefly discuss some of the challenges and obstacles facing film-makers working in the social realist mode as well as those which face critics, academics and students interested in this field.

British social realism: continuity/discontinuity

John Hill was, of course, quite correct in questioning Valerie Thorpe's assumption that there is an unbroken tradition of social realism in British film and television (see Introduction, Chapter 6 and Hill 2000b). It is dangerous to mix up different styles, forms and types of film practice. What this book has sought to do is to present a coherent overview of works that have by and large conformed to the realist urge identified by Raymond Williams (1974) whilst acknowledging differences in form and practice. The cycles, movements and moments featured in this book whilst not representing a continuous thread do take the previous 'social realisms' as their jumping off point – either as their inspiration or in reaction or response to previous film-makers versions of the 'real world' and the changes in society. Furthermore, as social realism has

come to be established as a recognisable 'form' or mode of filmic and televisual expression, it has accumulated a range of characteristics and conventions that are either unconsciously incorporated, or else playfully or ironically included, in contemporary social realist texts. As a consequence, contemporary 'Brit-Grit' has a pool of actors, shot in real, usually urban, locations, with recognisable authors who to varying degrees continue to play out the old interpretative tensions of the 'creative interpretation of actuality' approach.

One of the major discontinuities is the focus on the individual director. One of the main arguments against the British New Wave being described as such was the perceived lack of concern over authorial signatures coupled with the films being adaptations rather than the director's own original idea (see Wollen 1993). In the contemporary scene of course, these two features are a virtual prerequisite if British social realist texts are to flourish on the art house circuit.

We have seen, too, how themes, issues and representations change over time. This makes it almost impossible to pin down specific concerns beyond a preoccupation with British working class life and its perceived demise in the light of social, political and economic changes. There are, however, two specific trends or movements in British social realist texts:

• a movement away from the public and the social (the working class at work, struggles connected to the wider society or community) to the private and the personal (the focus on family life and problems with little reference to social, political and economic conditions).

• the demise of the traditional working class and their definition in terms of what they consume rather than what they produce or do, and the subsequent increased attention on what Monk refers to as the 'underclass'.

Much has been made of hybridity in contemporary social realist texts and, whilst this is important, it is of equal importance to understand that hybridity has been present in all the cycles, movements and moments mentioned in previous chapters and, indeed, it is this tendency which in part helps to move social realism forward. Grierson and his contemporaries were familiar with Soviet montage cinema and reacted to its challenge in different ways; Jennings was fascinated with surrealism; the Free Cinema directors were influenced by the French New Wave and Italian Neo-realism, as well has the poetic cinema of Jennings. Film-makers like Bernard, Leigh,

Loach, and Oldman exhibit differing forms of hybridity in their work – from the tension implied in Loach's work between melodrama (situations and close-ups) and documentary realism, to the social surrealism of Mike Leigh and Oldman's innovative use of montage.

Another key defining feature of social realist texts, as we have seen, is their position in relation to mainstream films. The Griersonian units produced state- and corporate-sponsored documentaries and this set them apart from mainstream film production and mainstream exhibitors and audiences. One of the key principles of the Free Cinema movement was to retain commercial freedom and this meant retaining an independence from mainstream film production. Some of the Free Cinema directors went on to set up and produce films for their own independent production company, Woodfall Films, which retained its freedom to cover subjects the directors wanted in ways they wanted, but which sat alongside the mainstream film production and even achieved success with mainstream audiences. In the 1980s we have seen how Channel 4, among others, encouraged independent producers to make challenging films, among them social realist texts like *My Beautiful Laundrette*, *Letter to Brezhnev*, and *Rita, Sue and Bob, Too*. These stood in stark contrast to the big box-office pictures like *Gandhi* (1982), *Chariots of Fire* (1981) and Merchant-Ivory films like *A Room With a View* (1985), and *Howard's End* (1992).

In the contemporary scene, however, the question of independence is a complex issue, for whilst film-makers like Ken Loach and Mike Leigh have set up production companies, they have to compete with films backed by American money (or French capital in the case of *Nil By Mouth*) which offer an easily exportable vision of the nation like *Four Weddings and a Funeral*, *Notting Hill*, *Sliding Doors*, and *Shakespeare in Love* (1998). It could be argued that the tradition of independence at the level of industry which has defined the production of British social realist films is not so much under attack but rather undergoing a process of assimilation. This process is occurring within a system that aims to accommodate consumers of all tastes and which points them in the appropriate directions: the multiplex or the 'art house cinema'.

Furthermore, it is becoming increasingly difficult to define a film as 'British'. As Justine Ashby and Andrew Higson note:

Scholarly debates about British cinema have questioned the concept of an indigenous, discrete national cinema, but as transnational

funding becomes the norm, this argument may quickly be settled by trends in film production rather than by developments in film scholarship. (2000: 15)

Social realism is still considered to be somehow not big enough for the cinema screen. It is, some argue, more suited to the private world of the home via the television than the oversized, fantasy world of the cinema. Yet it is still considered to be a mode which connotes quality not so much in terms of its content, but in relation to the specific oeuvre delivered by the author/director. On television, social realist films and dramas are highly prized. For example, a Broadcasting Research Unit (BRU) report argued that quality broadcasters should 'exemplify such standards which are concrete expressions of public conscience, collectively arrived at, individually practised' (BRU 1989: 6). Furthermore, the report contends that British television fiction could be more important than factual programmes. Speaking of the 1980s it contends:

> The fiction of the Eighties has touched on 'truth' in an imaginative and recognisable way. It is no accident that *Bread* is a popular comedy, that – earlier – *Boys from the Blackstuff* told more about the underside of Britain than a raft of factual programmes would have done. (1989: 16)

In recent times both the BBC and Channel 4 have continued to support, commission and screen contemporary social realist films and dramas, and these too, continue the two trends in social realist texts identified above and discussed throughout the course of the book.

Contemporary British social realism: some issues and questions

There are a number of issues and questions, changes and developments that need to be addressed by film-makers, academics and students alike in relation to British social realism. First and foremost it might be fruitful to re-consider the term 'British social realism'. How meaningful is it to use this term when every constituent part of the term is subject to flux and change? Has 'British' social realism, for example, ever been 'British'? Or has it rather been English? What are the implications for any concept of British social realism post-devolution? And in this post-devolution climate,

will we be speaking of Welsh social realism, or Scottish social realism, respectively? As Julia Hallam argues, this is as yet an unknown quantity:

Whether the devolution of film production can contribute in the longer term to the development of a diverse film and media culture that projects the experiences of Britain's multifarious communities remains a challenge to policy makers, media development agencies and the film-makers which they support. (2000: 271)

In a multicultural society, 'British' can mean many different things to different groups. But film-makers are not exploring this in social realist texts to the same extent as, for example, the position of white working class men.

Our understanding of the 'social' has changed and, as we have seen, the representation of the social and the public has given way to an increased representation of the private and the personal. Pawlikowski's *Last Resort* is the first social realist film to explore the new, privatised world of cyberporn, a social problem for the twenty-first century.

The focus on the private and the personal, it has been argued, undermines the 'social' message and meaning as we focus on the individual or family and their struggles without making connections to wider political, economic and social factors. Yet there is a further way that the 'social' could be seen to be in a state of change, even crisis. There has been a fragmentation of the national audience as a result of, first, the cable and satellite television revolution in the 1980s and 1990s and now with the advent of digital television. This means that on television it is increasingly unlikely that programmes will become 'events', in Caughie's term.

In the light of increased choice, social realist films screened either in art house cinemas or on the 'minority channels' BBC2 and Channel 4, reach shrinking audiences. It is back to the old problem experienced by film-makers working in ways outside of the mainstream: finding the audience.

'Realism' and our conception of what is real, and our acceptance of what is a realistic convention, is changing. In recent years so-called 'Reality TV' has had an impact on documentary form and has also influenced other areas of visual culture and one might consider diverse projects ranging from Tracey Emin's bed, to *The Blair Witch Project* (1999) as examples since they all engage directly with 'the real' and the personal in different ways. What, if any, impact Reality TV will have on British social realist texts is unclear

– although Pawlikowski's use of surveillance-style camera work in *Last Resort* may point the way. At the very least Reality TV may make gritty social realism as we have come to know it along with all its conventions look stilted and 'unrealistic'. It might not be too presumptuous to imagine that the trend towards the personal and the private will be further progressed.

In conclusion, then, it appears that it may not be possible to speak of British social realism in the same ways, and that the term 'British social realism' may no longer be accurate or relevant. I am not suggesting we abandon it completely but rather that we question it and we question film production, distribution and content with those criticisms in mind. If British social realist film production is to survive, it needs to find its audience. Increasingly, British films are required to contain an international appeal. Tried and tested British exports have been successful because they managed to market certain images of Britain which are found to be attractive elsewhere. Thomas Elsaesser argues that:

> British films ... have been rather successful in marketing and packaging the national literary heritage, the war years, the countryside, the upper classes and elite education, and in so doing have also succeeded in constructing and circulating quite limiting and restricted images of Britain. (Elsaesser in Malik 1996: 214)

This success, it seems, could mean that it is already too late for British social realism. We began this book with the words of Alan Parker, then director and now head of the Film Council, and it is with him we shall end, since the best hopes of developing a sustainable film industry in Britain largely rest with him and his organisation. In his 1997 British Academy Lecture, Parker states:

> We as a nation – be it in the worlds of music, fashion, art, cinema or television – are perfectly poised in the new communication age, not just to be a marginal player, but to show the world our Full Monty. (1997: 9)

The working classes are now added to Elsaesser's 'exportable images' to be consumed, but is it a utopian vision of the working classes, a Blairite vision in which 'Things Can Only Get Better'? There is evidence that class politics as a major preoccupation of British social realist texts have been

abandoned in favour of autobiography and nostalgia. Which categories of representation it chooses to embrace in the future remains to be seen. But it seems clear that the trend away from the public and the social to the private and the personal looks set to continue.

NOTES

Chapter 1

1 According to Andrew Higson, surface realism is 'an iconography which authentically reproduces the visual and aural surfaces of the "British way of life"' (1996: 136).

Chapter 2

1 The documentary movement is a term used to describe the collective work of certain film-makers working in the documentary mode under a state-sponsored system throughout the 1930s and 1940s.

Chapter 3

1 Mass Observation was a social survey association interested in the social and cultural habits of the newly conceptualised 'mass society'. Humphrey Jennings was a key member of the association. Jennings, amateur anthropologist Tom Harrisson, and poet Charles Madge launched the survey in 1936 by getting a sample of fifty people from all over Britain to submit detailed reports about their daily lives. A list of topic areas of interest for Jennings and Mass Observation included an anthropology of the football pools, female taboos about eating, the private lives of midwives, and even bathroom behaviour – see K. Jackson 1993: xiv–vi. Equally interesting and extremely detailed work is to be found in J. Richards & D. Sheridan (eds) 1987.

Chapter 4

1 For further discussions on Dearden see A. Burton (ed.) (1987) *Liberal Directions*. London: Flicks Books.
2 Peter Wollen, however, contends that the British New Wave do not constitute a new wave in the same sense as other New Waves, notably the French Nouvelle Vague, largely because of their tendency to adapt novels and stage plays, and because of their lack of authorial signatures – for further discussion see P. Wollen in Lester Friedman (ed.) (1993) *Fires Were Started: British Cinema and Thatcherism*. London: UCL Press.

3　Steve Chibnall argues that the British New Wave films were part of a wider trend to extend representations and points to the work of directors such as Val Guest, Ken Hughes, Joseph Losey and J. Lee Thompson – see Chibnall in S. Chibnall & R. Murphy (eds) (1999) *British Crime Cinema*.

4　R. Murphy 1992: 18. Some of the money was Eady Money, funds available via a tax on tickets paid by the exhibitors, named after Sir Wilfred Eady, who developed the policy. Eady money was officially legislated for in 1957.

Chapter 5

1　See R. Murphy, Sixties British Cinema (1992: 256–75) and J. Park (1990) British Cinema: The Lights That Failed for discussions on the withdrawal of American production and support.

2　See T. Nichols in P. Block, Managing The Media (2001:131–145).

3　This was not the end of the attack on youth of Thatcher's administration. After 1988 benefits were not payable to anyone under the age of 18 and young people could not study full-time and receive benefits.

Chapter 6

1　It should be noted, however, that its commitment to film has been reconfirmed in the light of the channel's successful launch of Film Four subscription channels.

2　These kinds of moral panics have their origins in the generational concerns on the effects of mass culture on youth from the 1950s.

3　It could be argued that Gary Oldman shares this autobiographical approach with other British directors working in the social realist mode, notably Bill Douglas and Terence Davies. However, Oldman's star status can be seen to undermine his credentials as a 'working class film-maker' and may make any attempt at political or social comment problematic from this perspective.

4　Cinematographer Hugo Lucyc-Wyhowski in James 1997: 8.

FILMOGRAPHY

1984 (1984, Michael Radford, UK)
American Pie (1999, Paul Weitz, US)
Baby of Macon, The (1993, Peter Greenaway, Belg./Fr./Ger./UK)
BabyMother (1998, Julien Henriques, UK)
Bean (1997, Mel Smith, UK)
Bhaji on the Beach (1993, Gurinder Chadha, UK)
Bicycle Thieves (1948, Vittorio De Sica, It.)
Billy Liar! (1963, John Schelsinger, UK)
Bitter Rice (1948, Giuseppe De Santis, It.)
Blair Witch Project, The (1999, Daniel Myrick and Eduardo Sanchez, US)
Bloody Kids (1979, Stephen Frears, UK)
Blue Lamp, The (1950, Basil Dearden, UK)
Brassed Off (1996, Mark Herman, UK/US)
Britannia Hospital (1982, Lindsay Anderson, UK)
Career Girls (1997, Mike Leigh, UK)
Cathy Come Home (1966, Ken Loach, UK)
Chariots of Fire (1981, Hugh Hudson, UK)
Coal Face (1935, Alberto Cavalcanti, UK)
Cook, The Thief, His Wife and Her Lover, The (1989, Peter Greenaway, Fr./Neth.)
Cosh Boy (1952, Lewis Gilbert, UK)
Dangerous Liaisons (1988, Stephen Frears, US)
Days of Hope (1975, Ken Loach, UK)
Diary for Timothy, A (1944–45, Humphrey Jennings, UK)
Dim Little Island, The (1949, Humphrey Jennings, UK)
Distant Voices, Still Lives (1988, Terence Davies, UK)
Draughtman's Contract, The (1982, Peter Greenaway, UK)
Drifters (1929, John Grierson, UK)
East is East
Equus (1977, Sidney Lumet, US)
Family Life (1971, Ken Loach, UK)
Family Portrait (1950, Humphrey Jennings, UK)
Fires Were Started (1943, Humphrey Jennings, UK)
Four Weddings and a Funeral (1994, Mike Newell, UK)
Full Monty, The (1997, Peter Cattaneo, UK)
Gandhi (1982, Richard Attenborough, Ind./UK)
Girl With Brains in Her Feet, The (1997, Robert Bangura, UK)

Grifters, The (1990, Stephen Frears, US)
Handsworth Songs (1986, John Akomfrah, UK)
Heaven's Gate (1980, Michael Cimino, US)
Hi Fidelity (2000, Stephen Frears, US)
High Hopes (1988, Mike Leigh, UK)
Housing Problems (1936, Edgar Anstey and Arthur Elton, UK)
Howard's End (1992, James Ivory, UK)
If... (1968, Lindsay Anderson, UK)
In Which We Serve (1942, Noel Coward, UK)
Industrial Britain (1933, Robert Flaherty and John Grierson, UK)
Ishtar (1987, Elaine May, US)
Jaws (1975, Steven Speilberg, US)
Jubilee (1978, Derek Jarman, UK)
Kes (1969, Ken Loach, UK)
Kind of Loving, A (1962, John Schelsinger, UK)
Ladybird, Ladybird (1993, Ken Loach, UK)
Last of England, The (1987, Derek Jarman, UK/Ger.)
Last Resort (2001, Pavel Pawlikowski, UK)
Leather Boys, The (1963, Sidney J. Furie, UK)
Letter to Brezhnev (1985, Chris Bernard, UK)
Lion Has Wings, The (1939, Michael Powell, UK)
Listen to Britain (1942, Humphrey Jennings, UK)
Loneliness of the Long Distance Runner, The (1962, Tony Richardson, UK)
Look Back in Anger (1958, Tony Richardson, UK)
Looks and Smiles (1981, Ken Loach, UK)
Love on the Dole (1941, John Baxter, UK)
L-Shaped Room, The (1962, Bryan Forbes, UK)
Made in Britain (1982, Alan Clarke, UK)
Meantime (1983, Mike Leigh, UK)
Millions Like Us (1943, Frank Launder, UK)
Moana (1925, Robert Flaherty, US)
Momma Don't Allow (1955, Karel Reisz and Tony Richardson, UK)
My Beautiful Laundrette (1985, Stephen Frears, UK)
My Name is Joe (1998, Ken Loach, Fr./Ger./It./Sp./UK)
Navigators, The (2001, Ken Loach, Ger./Sp.)
Night Mail (1936, Harry Watt and Basil Wright, UK)
Nil By Mouth (1997, Gary Oldman, Fr./UK)
Nine Men (1943, Harry Watt, UK)
Notting Hill (1999, Roger Michell, US/UK)
O! Dreamland (1953, Lindsay Anderson, UK)
Ploughman's Lunch, The (1983, Richard Eyre, UK)
Poor Cow (1967, Ken Loach, UK)
Price of Coal, The (1977, Ken Loach, UK)
R.H.I.N.O: Really Here In Name Only (1982, Jane Howell, UK)
Raining Stones (1993, Ken Loach, UK)
Rank and File, The (1971, Ken Loach, UK)
Ratcatcher (1999, Lynne Ramsay, UK)
Riff Raff (1991, Ken Loach, UK)
Rita, Sue and Bob, Too (1986, Alan Clarke, UK)
Rome, Open City (1945, Roberto Rossellini, It.)
Room at the Top (1959, Jack Clayton, UK)
Room With a View, A (1985, James Ivory, UK)
Saigon: Year of the Cat (1987, Stephen Frears, UK)
Sammy and Rosie Get Laid (1987, Stephen Frears, UK)
San Demetrio, London (1943, Charles Frend, UK)
Sapphire (1959, Basil Dearden, UK)
Saturday Night and Sunday Morning (1960, Karel Reisz, UK)
Scream (1996, Wes Craven, US)

Scrubbers (1983, Mai Zetterling, UK)
Scum (1979, Alan Clarke, UK)
Secrets and Lies (1996, Mike Leigh, UK)
Shakespeare in Love (1998, John Madden, UK)
Shoeshine (1946, Vittorio De Sica, It.)
Silent Village, The (1943, Humphrey Jennings, UK)
Sliding Doors (1998, Peter Howitt, UK/US)
Spare Time (1939, Humphrey Jennings, UK)
Stella Does Tricks (1997, Coky Giedroyc, UK)
Target For Tonight (1943, Harry Watt, UK)
Taste of Honey, A (1961, Tony Richardson, UK)
This Happy Breed (1944, David Lean, UK)
This Sporting Life (1963, Lindsay Anderson, UK)
Tina Goes Shopping (1999, Penny Woolcock, UK)
Tina Takes a Break (2001, Penny Woolcock, UK)
True Story of Lili Marlene, The (1944, Humphrey Jennings, UK)
TwentyFourSeven (1997, Shane Meadows, UK)
Up 'n' Under (1998, John Godber, UK)
Up the Junction (1965, Ken Loach, UK)
War Zone, The (1999, Tim Roth, UK)
Waterloo Road (1944, Sidney Gilliat, UK)
Waterworld (1995, Kevin Reynolds, US)
We Are The Lambeth Boys (1958, Karel Reisz, UK)
When I Was Twelve (2001, Dominic Savage, UK)
Whistle Down the Wind (1961, Bryan Forbes, UK)
Wish You Were Here (1987, David Leland, UK)
Words for Battle (1941, Humphrey Jennings, UK)

Television programmes/series (Network, Date first transmitted)

Albion Market (Granada TV, 1985)
Auf Wiedersehen Pet (Central TV, 1982)
Birds of a Feather (BBC, 1989)
Boys from the Blackstuff, The (BBC, 1982)
Bread (BBC, 1986)
Brookside (Channel 4, 1982)
Byker Grove (BBC, 1990)
Care (BBC, 2001)
Colbys, The (ABC, 1985)
Coronation Street (Granada TV, 1960)
Dallas (CBS, 1978)
Dixon of Dock Green (BBC, 1955)
Dynasty (ABC, 1981)
Eastenders (BBC, 1985)
Falcon Crest (CIC, 1981)
Flamingo Road (NBC, 1981)
Grange Hill (BBC, 1978)
Howard's Way (BBC, 1985)
Knot's Landing (CBS, 1979)
Lovejoy (BBC, 1986)
North and South (ABC, 1985)
Only Fools and Horses (BBC, 1981)
Oprah (NBC, 1986)
Prospects (Thames, 1984)
Thorn Birds, The (ABC, 1983)
Tucker's Luck (BBC, 1983)
Young Ones, The (BBC, 1982)
Z Cars (BBC, 1962)

BIBLIOGRAPHY

Aitken, I. (1990) *Film and Reform: John Grierson and the Documentary Film Movement*. London: Routledge.

Anderson, L. (1982) 'Only Connect: some aspects of the work of Humphrey Jennings', in M. L. Jennings (ed.) *Humphrey Jennings: Filmmaker, Painter, Poet*. London: BFI/Riverside Studios, 53–9.

Armes, R. (1971) *Patterns of Realism*. London: Tantivy Press.

Ashby, J. & A. Higson (2000) 'Introduction', in J. Ashby & A. Higson (eds) *British Cinema Past and Present*. London: Routledge, 1–17.

____(eds) (2000) British Cinema Past and Present. London: Routledge.

Aspinall, S. (1983) 'Women, Realism and Reality in British Films 1943–53', in J. Curran & V. Porter (eds) *British Cinema History*. London: Weidenfeld and Nicholson, 272–93.

Barr, C. (1977) *Ealing Studios*. London: Cameron and Tayleur.

____(ed.) (1986) *All Our Yesterdays*. London: BFI.

Bazin, A. (1967) *What is Cinema? Vol. 1*. Berkeley: University of California Press.

____ (1971) *What is Cinema? Vol. 2*. Berkeley: University of California Press.

____(1999) 'article title' in Braudy, Cohen & Mast (eds) pub/place/pp

Block, P. (2001) *Managing the Media*. London: Focal Press.

Branston, G. & R. Stafford (1996) *The Media Students Book*. London: Routledge.

Broadcasting Research Unit (1989) *Quality in Television – Programmes, Programme-makers, Systems*. London: John Libby.

Brown, G. (2000) 'Something for Everyone: British Film Culture in the 1990s', in R. Murphy (ed.) *British Cinema of the 90s*. London: BFI, 27–37.

Brunsdon, C. (2000) 'Not Having It All: Women and Film in the 90s', in R. Murphy (ed.) *British Cinema of the 90s*. London: BFI, 167–77.

Burton, A. (ed.) (1987) *Liberal Directions*. London: Flicks Books.

Caughie, J. (2000) *Television Drama: Realism, Modernism and British Culture*. Oxford: Oxford University Press.

Carroll, N. (1996) *Theorising the Moving Image*. Cambridge: Cambridge University Press.

Chapman, J. (2000) 'Cinema, Propaganda and National Identity: British Film and the Second World War', in J. Ashby & A. Higson (eds) *British Cinema Past and Present*. London: Routledge, 193–206.

Chibnall, S. (1999) 'Ordinary People: 'New Wave' Realism and the British Crime Film 1959–1963', in S. Chibnall & R. Murphy (eds) *British Crime Cinema*. London: Routledge, 94–109.

Chibnall, S. & R. Murphy (eds) (1999) *British Crime Cinema*.

Dixon, B. & C. Dupin (2001) 'Soup Dreams', *Sight and Sound*, March, 2, 3, 28–30.

Dodd, K. & P. Dodd (1996) 'Engendering the Nation: British documentary film 1930–1939', in A. Higson (ed.) *Dissolving Views: Key Writings on British Cinema*. London: Cassell, 38–50.

Dyer, R. (1981) 'Introduction', in R. Dyer, C. Geraghty, M. Jordan, T. Lovell, R. Patterson & J. Stewart (eds) *Coronation Street*. London: BFI, 1–8.

Ellis, J. (1978) 'Art, Culture, Quality', *Screen*, 16, 1, 77–94.

Elsaesser, T. (1984) 'Images for England (and Scotland and Ireland and Wales)', in *Monthly Film Bulletin*, March, 267–70.

Enticknap, L. (2000) 'This Modern Age and the British Non-Fiction Film', in J. Ashby & A. Higson (eds) *British Cinema Past and Present*. London: Routledge, 207–20.

Forbes, J. (1985) 'A Letter to Breshnev', in *Monthly Film Bulletin*, October, 310.

Friedman, L. (ed.) (1993) *British Cinema and Thatcherism: Fires Were Started*. London: UCL Press.

Fuller, G. (ed.) (1998) *Loach on Loach*. London: Faber.

Geraghty, C. (2000) *British Cinema in the Fifties: Gender, Genre and the New Look*. London: Routledge.

____(2001) 'Cinema and Social Space', *Framework: The Journal of Cinema and Media*. Available online at: http://www.frameworkonline.com/42cg.htm

Giles, P. (1993) 'History With Holes: Channel Four Television Films of the 1980s', in L. Friedman (ed) *British Cinema and Thatcherism: Fires Were Started*. London: UCL Press, 72–92.

Hacker, J. & D. Price (1991) *Take Ten: Contemporary British Film Directors*. Oxford: Clarendon Press.

Hallam, J. (2000) 'Film, Class and National Identity: Re-imagining communities in the age of devolution', in J. Ashby & A. Higson (eds) *British Cinema Past and Present*. London: Routledge, 261–73.

Hallam, J. & M. Marshment (2000) *Realism and Popular Cinema*. Manchester: Manchester University Press.

Hanson, S. (2000) 'Spoilt For Choice? Multiplexes in the 90s', in R. Murphy (ed.) *British Cinema of the 90s*. London: BFI, 48–59.

Hardy, F. (1979) *John Grierson: A Documentary Biography*. London: Faber and Faber.

Hartog, S. (1983) 'State Protection of a Beleaguered Industry', in J. Curran & V. Porter (eds) *British Cinema History*. London: Weidenfeld and Nicolson, 59–73.

Hayward, S. (2001) *Key Concepts in Cinema Studies*. London: Routledge.

Higson, A. (1993) 'Representing the National Past', in L. Friedman (ed.) *British Cinema and Thatcherism: Fires Were Started*. London: UCL Press, 109–29.

____(1995) *Waving the Flag: Constructing a National Cinema in Britain*. Oxford: Oxford University Press.

____(1996) 'Space, Place, Spectacle: Landscape and Townscape in the "Kitchen Sink" Film', in A. Higson (ed.) *Dissolving Views: Key Writings on British Cinema*. London: Cassell, 133–56.

Hill, J. (1983) 'Working Class Realism and Sexual Reaction: some theses on the British New Wave', in J. Curran & V. Porter (eds) *British Cinema History*. London: Weidenfeld and Nicolson, 303–11.

____(1986) *Sex, Class and Realism*. London: BFI.

____(1999) *British Cinema in the 1980s: Issues and Themes*. Oxford: Clarendon Press.

____(2000a) 'Failure and Utopianism: Representations of the Working Class in British Cinema of the 1990s', in R. Murphy (ed.) *British Cinema of the 90s*. London: BFI, 178–87.

____(2000b) 'From the New Wave to "Brit-Grit": Continuity and Difference in Working Class Realism', in J. Ashby & A. Higson (eds) *British Cinema Past and Present*. London: Routledge, 249–60.

Hillier, J. & A. Lovell (1972) *Studies in Documentary*. London: Secker and Warburg/BFI.

Hogenkamp, B. (1986) *Deadly Parallels: Film and the Left in Britain 1929–39*. London: Lawrence and Wishart.

Hoggart, R. (1957) *The Uses of Literacy*. Harmondsworth: Penguin.

Hood, S. and T. Tabary-Peterssen (1997) *On Television*. London: Pluto Press.

Jackson, K. (ed.) (1993) *The Humphrey Jennings Reader*. London: Carcarnet Press.

James, N. (1997) 'Being There', *Sight and Sound*, November, 7, 10, 6–9.

Jennings, ? (1982)

Knight, D. (1997) 'Naturalism, Narration and Critical Perspective: Ken Loach and the experimental method', in G. McKnight (ed.) *Ken Loach: Agent of Challenge and Defiance*. Wiltshire: Flicks Books, 79–98.

Kracauer, S. ([1960] 1999) 'Theory of Film' in Braudy, Cohen & Mast (eds) *Film Theory and Criticism*. Oxford: Oxford University Press.

Krish, J. (1963) 'The New Realism and British Films', *Society of Film and Television Arts Journal*, Spring.

Kuhn, A. (1980) 'British Documentary in the 1930s and "Independence": Re-contextualising a Film Movement', in D. MacPherson (ed.) *British Cinema: Traditions of Independence*. London: BFI, 24–33.

Lacey, S. (1995) *British Realist Theatre: The New Wave in its Context*. London: Routledge.
Landy, M. (1991) *British Genres*. Princeton, New Jersey: Princeton University Press.
Leigh, J. (2002) *The Cinema of Ken Loach: Art in the Service of the People*. London: Wallflower Press.
Leigh, M. (2000) Available at http://film.guardian.co.uk/Feature_story/0,4120,148064,00.html. 17 March.
Loach, K. (2001) 'One-Track Mind', *The Guardian* (G2), 30 November, 9.
Lovell, T. (1996) 'Landscapes and Stories in 1960s British Realism', in A. Higson (ed.) *Dissolving Views: Key Writings on British Cinema*. London: Cassell, 157–77.
Lowenstein, A. (2000) 'Under-the-Skin-Horrors: Social Realism and Classlessness in Peeping Tom and the British New Wave', in J. Ashby & A. Higson (eds) *British Cinema Past and Present*. London: Routledge, 221–32.
Luckett, M. (2000) 'Image and Nation in 1990s British Cinema', in R. Murphy (ed.) *British Cinema of the 90s*. London: BFI, 88–99.
Malik, S. (1996) 'Beyond "The Cinema of Duty"? The Pleasures of Hybridity: Black British Films of the 1980s and 1990s', in A. Higson (ed.) *Dissolving Views: Key Writings on British Cinema*. London: Cassell, 202–15.
MacCabe, C. (1974) 'Realism and the Cinema: notes on some Brechtian theses', in *Screen*, 15, 2, 7–27.
____(1992) 'Subsidies, Audiences, Producers', in D. Petrie (ed.) *New Questions of British Cinema*. London: BFI, 24–37.
McArthur, C. (1975) 'Days of Hope', *Screen*, 16, 4, 139–44.
Macnab, G. (1997) 'Nil By Mouth', *Sight and Sound*, November, 7, 10, 55.
Marwick, A. (1982) *British Society Since 1945*. Harmondsworth: Penguin.
Millington, B. & T. Nels (1986) *Boys from the Blackstuff: Making a TV Drama*. London: Comedia.
Monk, C. (2000a) 'Underbelly UK: The 1990s Underclass Film, Masculinity and the Ideologies of "New" Britain', in J. Ashby & A. Higson (eds) *British Cinema Past and Present*. London: Routledge, 274–87.
____(2000b) 'Men in the 90s', in R. Murphy (ed.) *British Cinema of the 90s*. London: BFI, 156–66.
Murphy, R. (1989) *Realism and Tinsel: Cinema and Society in Britain 1939–1949*. London: Routledge.
____(1992) *Sixties British Cinema*. London: BFI.
____(ed.) (2000) *British Cinema of the 90s*. London: BFI.
Napper, L. (2000) 'British Cinema and the Middle Brow', in J. Ashby & A. Higson (eds) *British Cinema Past and Present*. London: Routledge, 110–23.
Nichols, T. (2001) 'British Film Policy' in P. Block (ed.) *Managing the Media*. London: Focal Press, 62–71.
Park, J. (1990)
Parker, A. (1997) 'Genre and Other Long Words', The British Academy Lecture, 20 October. London: BAFTA.
Penrose, R. (1982) 'Foreword', in M. L. Jennings (ed.) *Humphrey Jennings: Filmmaker, Painter, Poet*. London: BFI/Riverside Studios, 4.
Petley, J. (1986) 'Cinema and the State', in C. Barr (ed.) *All Our Yesterdays*. London: BFI, 31–46.
____(1992) 'Independent Distribution in the UK: problems and proposals', in D. Petrie (ed.) *New Questions in British Cinema*. London: BFI Working Papers, 83–94.
Pulver, A. (2001) 'Dreams Were Made of This', *The Guardian*, March 22. Available on-line at: http://film.guardian.co.uk/features/feat... 0,4120 ,460939,00.htm
Relph, M. (1961) *Film and Filming*, May, 24–5.
Richards, J. (1988) 'National Identity in British Wartime Films', in P. Taylor (ed.) *Britain and the Cinema in the Second World War*. London: Macmillan, 42–61.
____(2000) 'Rethinking British Cinema', in J. Ashby & A. Higson (eds) *British Cinema Past and Present*. London: Routledge, 21–34.
Richards, J. & D. Sheridan (eds) (1987)
Southwell, R. (2001) 'Media and Its Cultural Implications', in P. Block (ed.) *Managing the Media*. London: Focal Press, 118–58.
Sussex, E. (1975) *The Rise and Fall of British Documentary: The Story of the Film Movement Founded by John Grierson*. Berkeley: University of California Press.
Swain, J. (1985) 'From Liverpool With Love', *Stills*, May, 19, 53–5.
Thompson, E. P. (1980) *The Making of the English Working Class*. London: Gollancz.
Thorpe, V. (1999) 'Reality Bites (Again)', *The Observer*, Guardian Film Unlimited website. Available online at http://www.film.guardian.co.uk/feature_story/observer/0''52399'00html

Tulloch, J. (1990) *Television Drama: Agency, Audience, Myth*. London: Routledge.
Watt, H. (1974) *Don't Look at the Camera*. London: Elek.
Williams, A. (1992) *Republic of Images: A History of French Filmmaking*. London: Harvard University Press.
Williams, C. (ed.) (1980) *Realism and the Cinema*. London: Routledge and Kegan Paul.
Williams, R. (1974) 'A Lecture on Realism', *Screen*, 18, 1, 61–74.
Wollen, P. (1993) 'The Last New Wave: Modernism in the British Films of the Thatcher Era', in L. Friedman (ed.) *British Cinema and Thatcherism: Fires Were Started*. London: UCL Press, 35–51.